HEBRIDEAN LIGHT

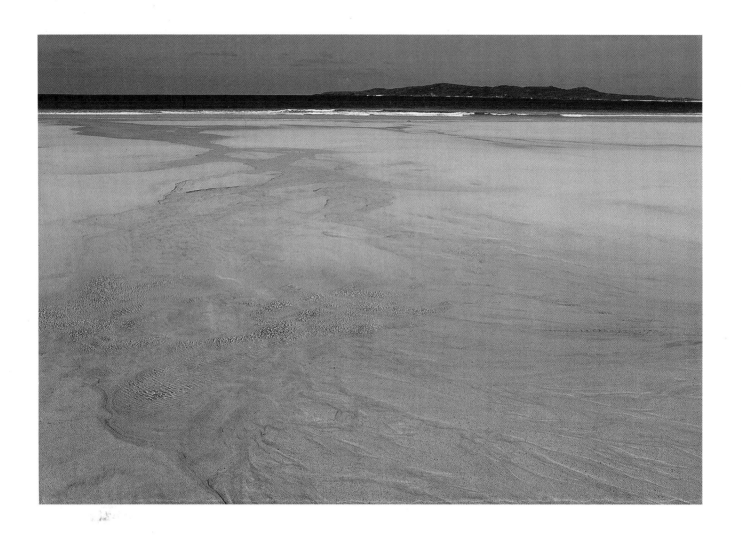

Luskentyre, Harris

HEBRIDEAN LIGHT

PHOTOGRAPHS BY
GUS WYLIE

WITH AN INTRODUCTION BY
ALAN WARNER

Birlinn

First published in Great Britain in 2003 by

Birlinn Ltd
West Newington House
10 Newington Road
Edinburgh

www.birlinn.co.uk

ISBN 1 84158 271 9

British Library Cataloguing-in-Publication Data
A catalogue record for this book is available on request from the British Library

Design by James Hutcheson

Printed and bound by Book Print S.L., Barcelona, Spain

CONTENTS

PREFACE

I SUPPOSE that if I have a reputation at all as a photographer, then it rests essentially on that body of work I have assembled since the early Seventies in the Western Isles of Scotland. My inspiration was a fundamental desire to record a particular way of life in transition. Stemming originally from a fond memory of a childhood in Scotland during World War Two, and of the Scottish people themselves, this desire was later underwritten by my love for the photographers of the American Dust Bowl of the Thirties — images of a very particular time, and again with people at their heart, quiet, passive and, above all, in black and white.

Yet, parallel to that, there was another side to my output of that time, with similar subject matter perhaps, but somehow entirely different in character, and concerned with quite different issues — the issues of colour and light and time. It was a kind of personal diary of an enthralled photographer, often walking alone and savouring the joys of that particular landscape under those equally particular skies — of water, of sand, of rain, mist, wind, and the rustle of the machair, taken on a second camera body always loaded with colour film, almost as a private passion. It became a different extension to my work and yet it has, apart from a brief showing at the Richard De Marco Gallery at the Edinburgh Festival of 1982, not really seen the light of day for more than twenty years. Indeed, that showing in Edinburgh effectively saw the end of that aspect of my Hebridean work, to which I have not returned to this day.

This is all the more surprising, perhaps, as I have not abandoned colour in my other work, and have consistently made essays of each region or country that I visit, starting with one on a Greyhound Bus to chart the route of a Chuck Berry song in the year of the Edinburgh show and, since then, small private visual diaries in Venice, Florence, Jerez, San Francisco, and New York, often linked to poems or songs in their assemblage. This desire to make a personal statement also saw me suddenly and spontaneously at the funeral of Diana, Princess of Wales as the car passed the Brent Cross flyover, an event I linked to Blake's 'The Sick Rose'. Most recent are an essay in southern Sweden in Ystad, and contribution to *The Great Book of Gaelic*, in support of a poem by Murdo Morrison — although that, I should add, was in monochrome.

I was recently reminded, though, of those early pleasures, by an expected trip that I made with a friend and his companions to the small island of Little Bernera in Lewis some three or four years ago. The friends in question were the family of the late Iain Macleod, MP, whose early and untimely death had preceded his burial in a small chapel in that lovely place, some twenty-five years earlier. We crossed in a hired boat the narrow stretch of water to the island on a day wreathed in sunshine, and duly made our way to the chapel. After looking at the adjustments to the fence and

walls to keep out unwanted cows, and savouring the moment, we left for a small beach on the north of the island to consume the sandwiches that had been kindly brought. For my sins, I dozed off. A tug at my sleeve wakened me and as I sat up I looked at the sight before me. The clear penetrating azure blue-green strip of sea over the thin line of pinkish sand led me to think that had I been brought there blindfolded and asked where I was, I would have not had the slightest idea – The Bahamas, perhaps, Fiji, West Africa, Sri Lanka, the Azores, the Seychelles? No, I had to remind myself, it was Little Bernera, in Lewis. This incident rekindled in me immediate memories of my earlier wanderings in the Islands – that unique and unforgettable experience of standing ankle deep on Luskentyre Beach in Harris, the light on the rippling water making fun of one's futile attempt to capture it on film but also even to establish precisely the surface of the water itself. It shimmered and danced, with the ultra-violet refection destroying any hope of gauging precisely the depth of the water. Yet not all of that pleasure rests in the glimmering sunlight, for it is equally present in the mist, or the shower. Often, as I looked at a young sea bird or a fleece or the lichen on a rock, I was reminded of the colours of Marion Campbell's tweed – the ochres, the browns, the greens and the greys that she herself had taken from the rocks in her work at Plocropool in Harris. Nor was the experience restricted to the landscape or the carved stone reliquaries still hidden in those fields and chapels, but was also to be found in the fading wallpapers of homes, in family photographs and the burning hearth, in well-fingered, gold-rimmed Bibles, and in walls and doors and signs. As I walked I filed them away and there they have remained for almost twenty-five years.

Thus it is that this small book affords me a very particular kind of pleasure and I am indeed grateful that it is so, and I am particularly grateful to the staff at Birlinn, under the gentle and considered guidance of Neville Moir and the watchful eye of James Hutcheson for bringing them together again. Many of the subjects have not only changed but are gone forever – the old post office at Barvas in Lewis, the decorative shell bus in South Uist, and I cannot but help think of the whereabouts of the butterfly-winged Madonna that hung behind that wonderful singer Nan MacKinnon in her home that she shared then with Jonathan Macleod in Vatersay, just south of Barra. And, let us be frank, I too am passing, and now that I look back on those particular days I am happy indeed that it was so, and that I was able, briefly, to share in their joys . . . and joys they certainly were.

Gus Wylie

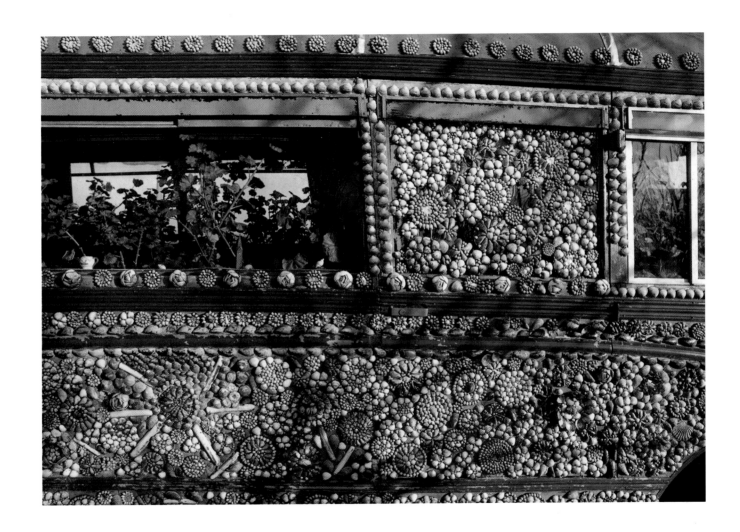

Shell bus, South Uist

INTRODUCTION

WHEN I was asked to introduce these photos by Gus Wylie I was a little daunted and didn't feel worthy. I'm no expert on photography, and Mr Wylie has been taking photographs in the Western Isles since the Seventies. I was only familiar with one poignant photo of his, showing a distant Highland home far behind a dominant Keep Out sign!

I needn't have worried. You'll be able to share my immediate delight when you too become familiar with these accessible and thoughtful photographs. Gus Wylie's work shows a clear formal intelligence, and of course a great sensitivity to light – Hebridean light. There is also an awareness of abstraction in his delightful images of water, sand and fish scales; seen through his lens the old post office at Barvas is a series of geometrical shapes neat against a line of sky as well as the old post office at Barvas. But, like so much contemporary photography, Gus Wylie's artistry is neither coldly intellectual nor formal.

It is debatable what a 'realistic' photograph is, but I feel I can say, that Gus Wylie's does not portray this part of Scotland sentimentally, or romantically, as so many mass-market calendars do. Instead we encounter insights about these islands.

What impresses me so much about these photos is their tactile honesty – the sense of the human in the work: both the humanity of the photographer, with his gentle, sensitive interiors of private homes, and the humanity of his subjects. Looking at his work has made me think again about the Western Isles and my own relationship with them.

When I was a child my parents ran a hotel in Oban and they worked long hours. Every July high season I would spend a fortnight on North Uist or Barra with their good friends, Morag and Donald Archie McDonald. Their son James was my age. Morag and Donald Archie were warm and humorous guardians and native Islanders. Gaelic was the language which surrounded me and James as we played around overgrown and abandoned tractors on a small Uist island. The photo of the surreal Uist bus, with its passengers of pansies and geraniums, the bus's bodywork a decorated infestation of countless shells, captures one of the most beautiful and strange memories of my youth.

Those summers, whole days were spent biking it to deserted sand beaches and doomed dams which tried to stop the Atlantic tide; or we searched for fallen rocket parts (from the nearby testing range), with only open ocean to the west. Always late, we pedalled home in twilight trying to beat darkness.

James and I were just children, shielded from the harshness of many things. I didn't recognise the symbolism of the abandoned, ruined farm machinery; to me the tractors were perfect Tiger tanks, the threshers howitzers! When I asked why there were no trees I was told of how in a big gale a piece of corrugated iron came turning over the machair, clattering across the yard, hit ten feet up the barn wall but

was held there by the wind until, three nights later, the force dropped momentarily, just enough for the metal sheet to crash down.

Notice how in the photo of the sheltering cockerel in a window duct a sapling has found refuge to root there also. This harsh natural world, which is far from my childhood idyll, is carefully shown, without dramatics, in Wylie's shots. So too is the world of work so often ignored in modern photographic imagery of Scotland. The weaving was not done in comfortable surroundings with modern equipment; the crofting, the fishing, the peat gathering and the shearing are hard, rough activities yet seem to arise from a necessary culture not modern capitalism and its grand plans. Quietly, there is a conflict being shown in these photographs, between these two modes of life. Those unforgettable hands pushed into the dyeing wool, the strong faces of the people don't need a soft-handed mainlander like me to eulogise them. They tell the stories.

The Western Isles have a culture we Scots find easy to forget; most of us are not part of that culture and we can be mocking of it, but something in many of us is protective about it, in all its subtle diversity. As I say, I used to know it better, from Mull, where my mum's family are from, and where she and my father lived and worked in the Fifties, to Barra, where, as a child, I picked cockles on the beach airstrip as the tide came in. The speed of modern life, in which I feel caught up, has taken me further from those islands and causeways much faster than I expected. I always tell myself I'll go back here or I'll go back there, but I don't. Something always gets in the way, though I know inside this is my loss. We are all in danger of losing something.

Due to the shrill demands of modern history, the Hebridean world has constantly to justify itself to the dominant culture on the mainland – or no other reason than that the island culture is distinctive and that it exists.

In these photos you contemplate this island universe – sky and water, stone and flesh – in virile colours and tactile textures. There's humour – a spectacular, plump, July Skye below the photographer's resting climbing boots! Look at the rich, low colours of the bobbins in Harris, but also let your eye be drawn deeper to the windowsill – the wear and tear shown in the old wood is a textured example of a working history.

Several very beautiful photographs are of dwellings at twilight; sepulchral and mysterious in their metallic blues. We feel Wylie's fascination and delight with this delicate, brief light. But this Hebridean twilight also shows, literally and metaphorically, an entire society slipping into invisibility.

There are forces in the world demanding we become the same and conform to uniform desires and the fulfilment of those

desires. We are being told what we want from our lives before we have decided for ourselves. We cannot choose. If you are not for, you are simply against. Terrible things are done in the name of 'the economy' today, and creating a single, monolithic culture is not the answer. Some places, by accident of geography, hang on to aspects of the past – some bad aspects, but some good. Gus Wylie's *Hebridean Light* shares a careful, tough beauty with us. It makes us think about our relations with the world around us and question our values. And to me that is a definition of art.

Alan Warner June 2003

PART ONE – HISTORY

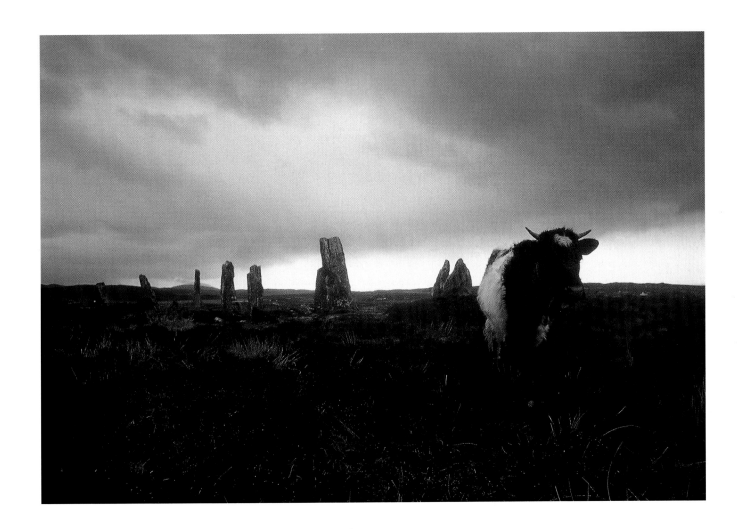

Approaching storm, Calanais, Lewis

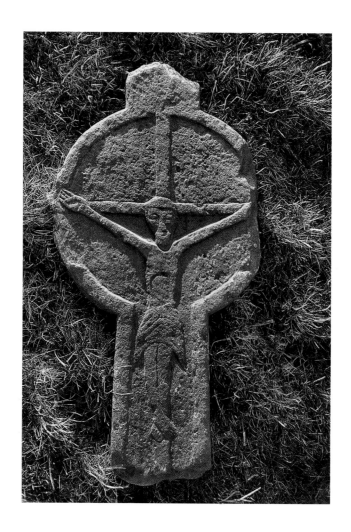

Calvary, carved stone, Islay

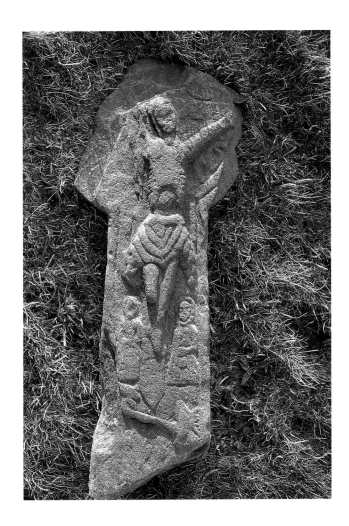

Carved crucifix, Islay

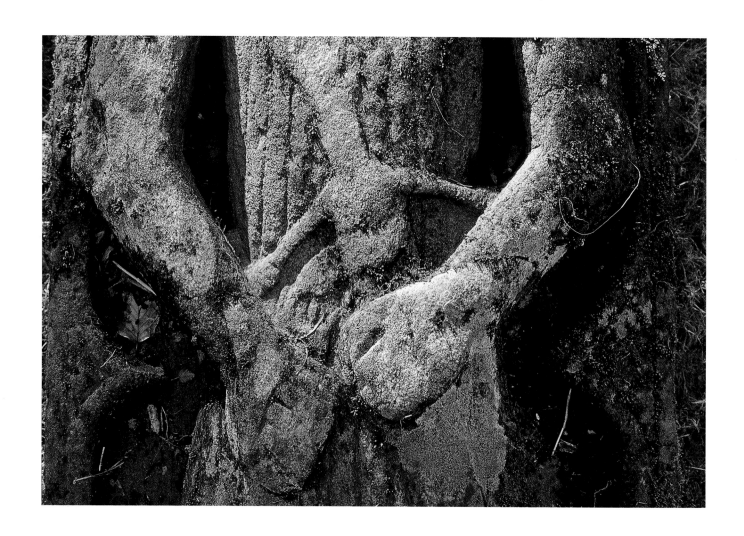

Carved effigy, (detail) Skeabost, Skye

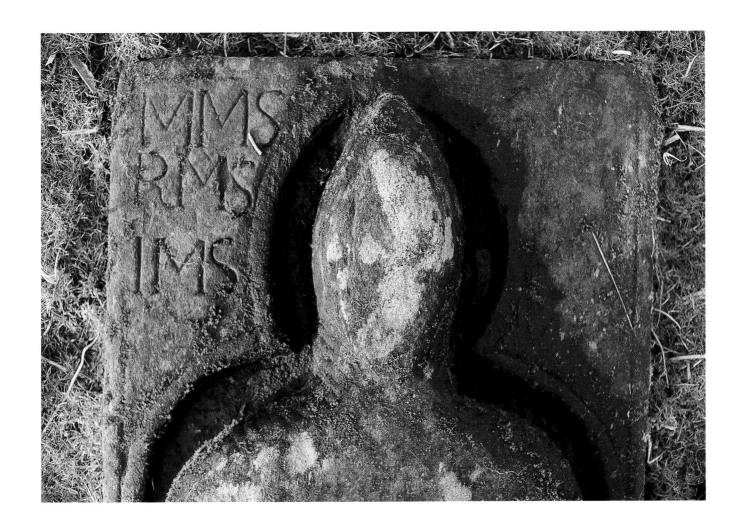

Skeabost, Effigy (detail)

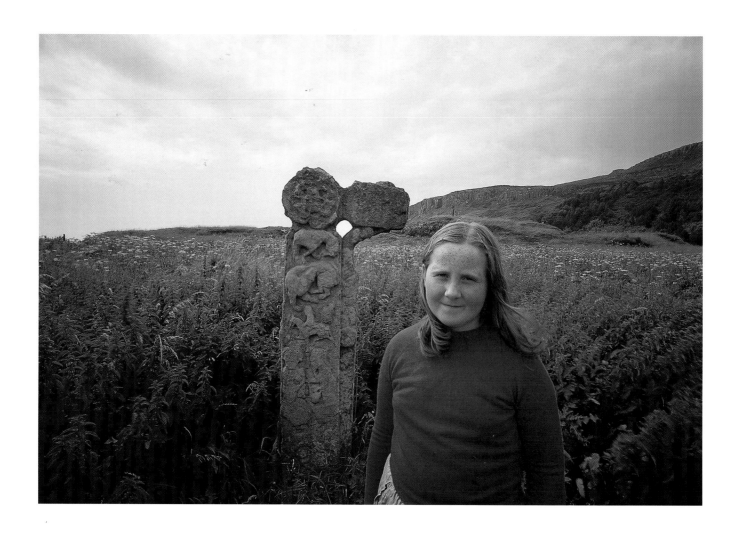

Child and sculptured cross, Canna

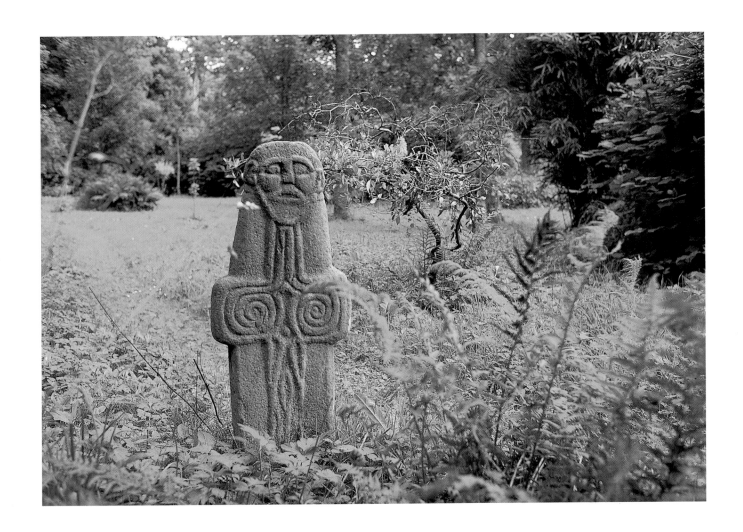

Carved effigy, in the grounds of Colonsay House, Colonsay

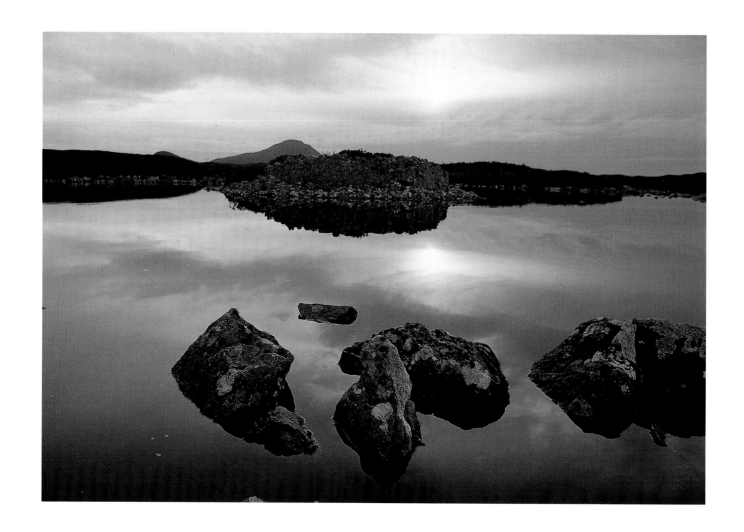

Loch Hunder, North Uist

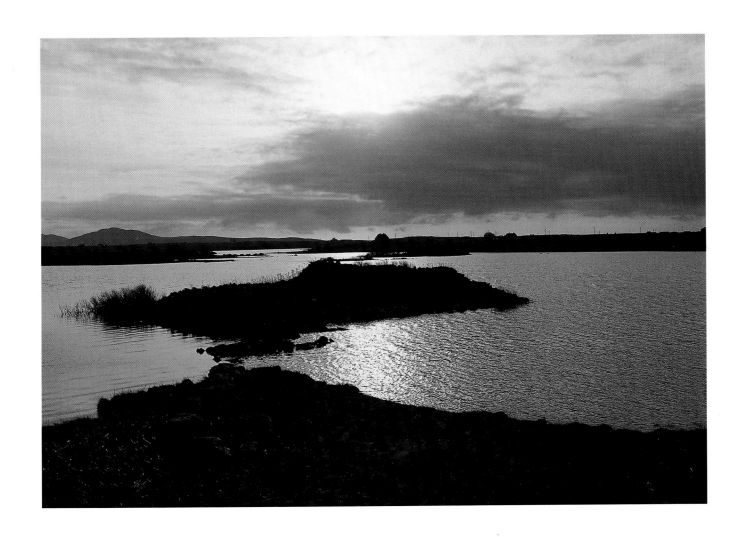

Morning light and Dun, South Uist

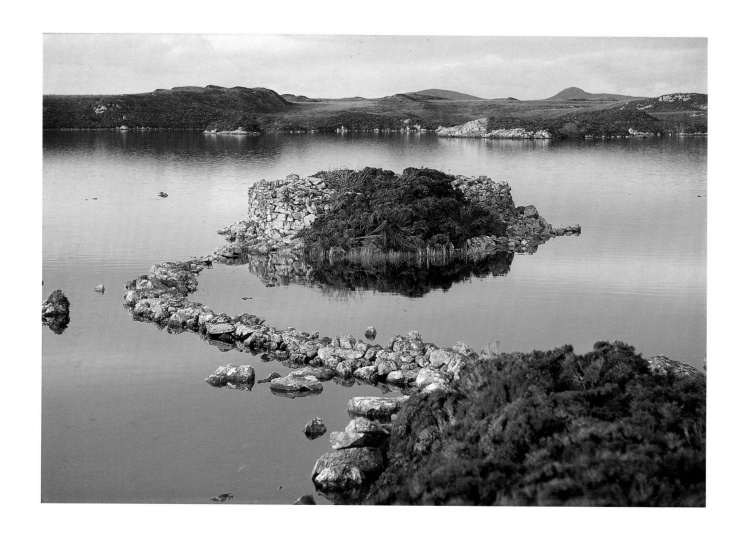

Dun Torcuil, North Uist

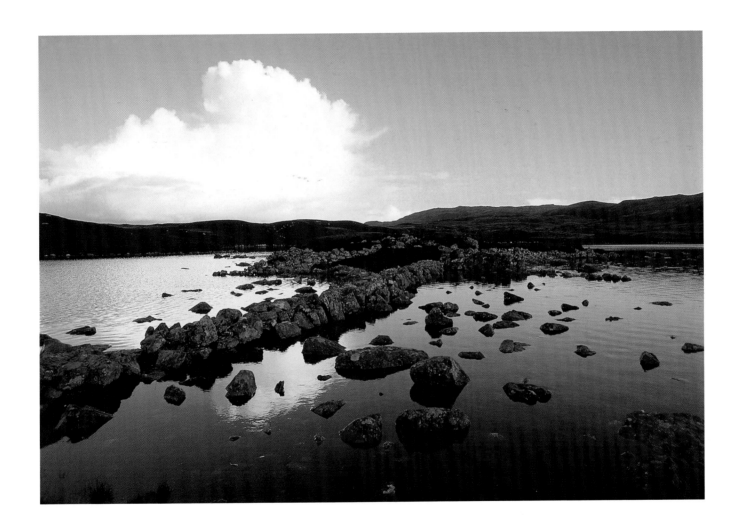

Dun and white cloud, North Uist

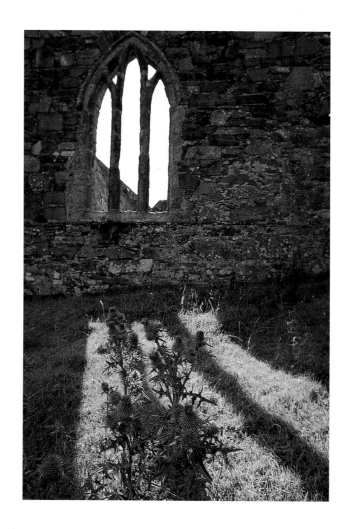

Window, Isle Oronsay

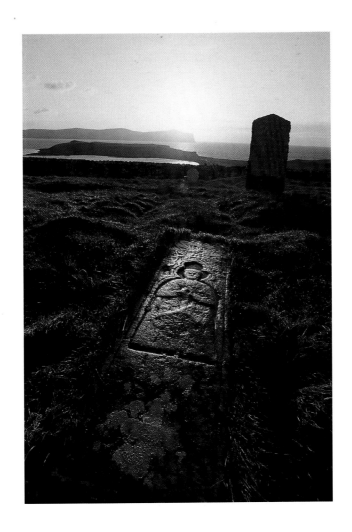

Carved gravestone, Kilmuir, Skye

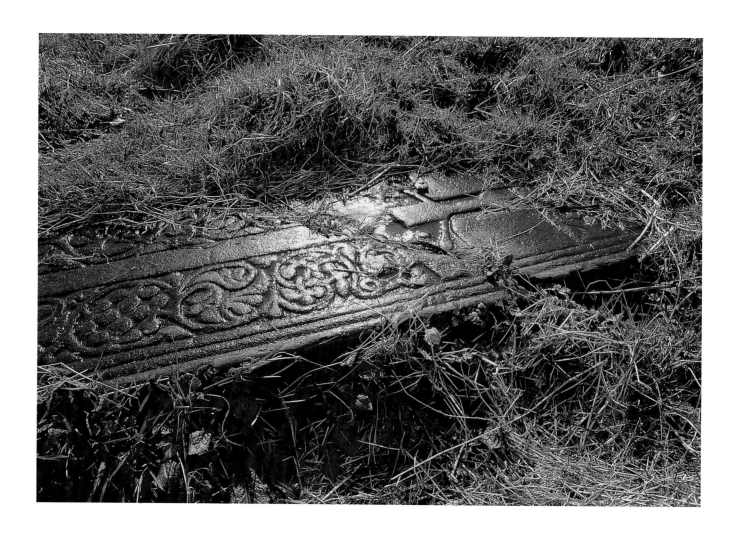

Claymore and carved slab, Islay

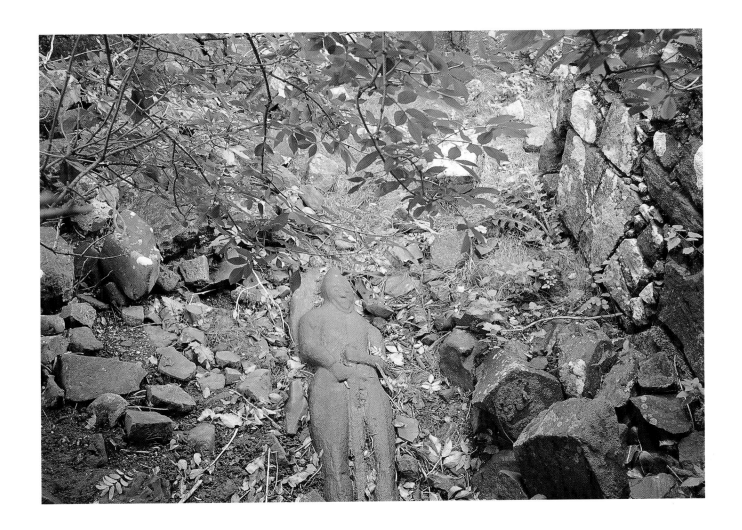

Effigy slab in chapel, Skeabost, Skye

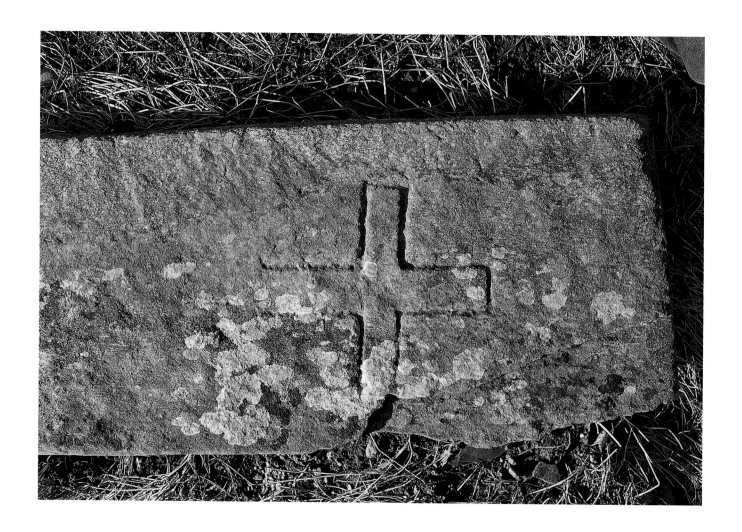

Incised cross, Islay

Bibles, Sleat Church, Skye

PART TWO – LIGHT

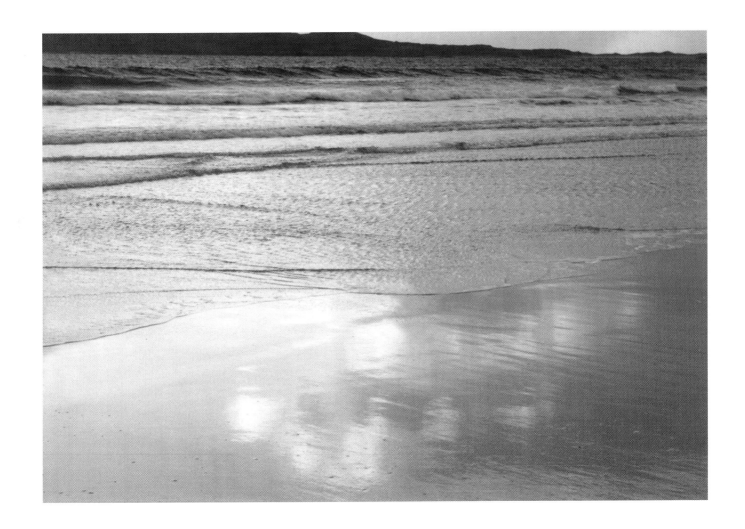

Clouds reflected in shore, Lewis

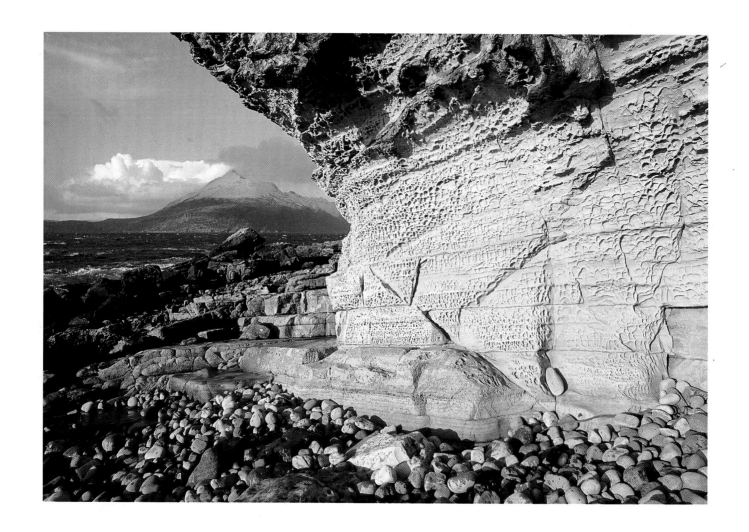

Winter morning, Elgol, Skye

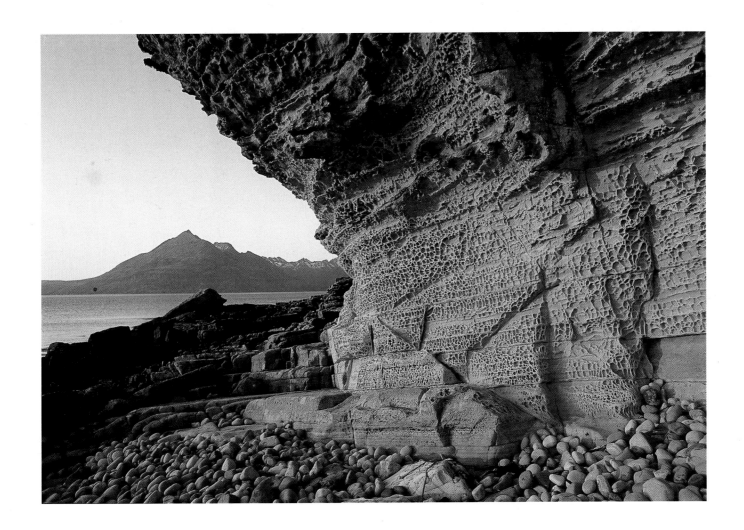

Autumn evening, Elgol, Skye

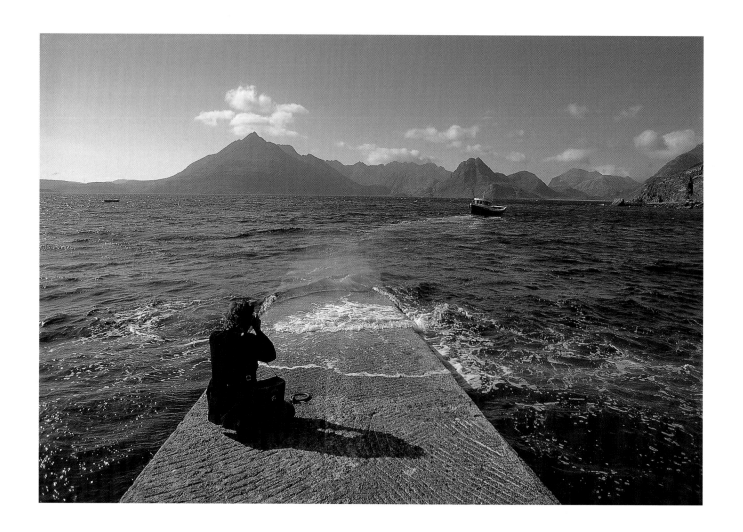

Slipway and Loch Slapin, Skye

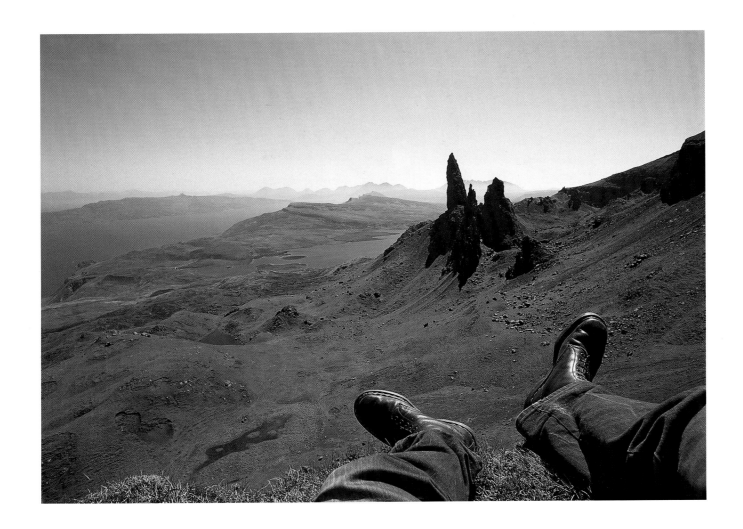

Relaxing at the Storr, Skye

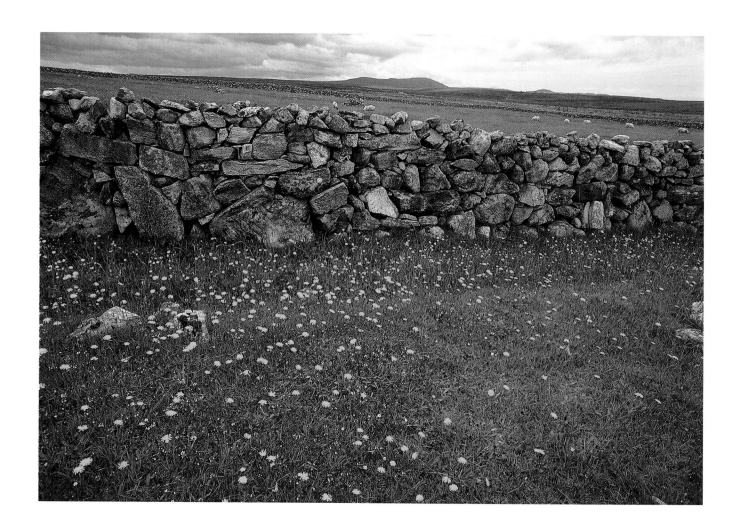

Drystone wall, Lewis

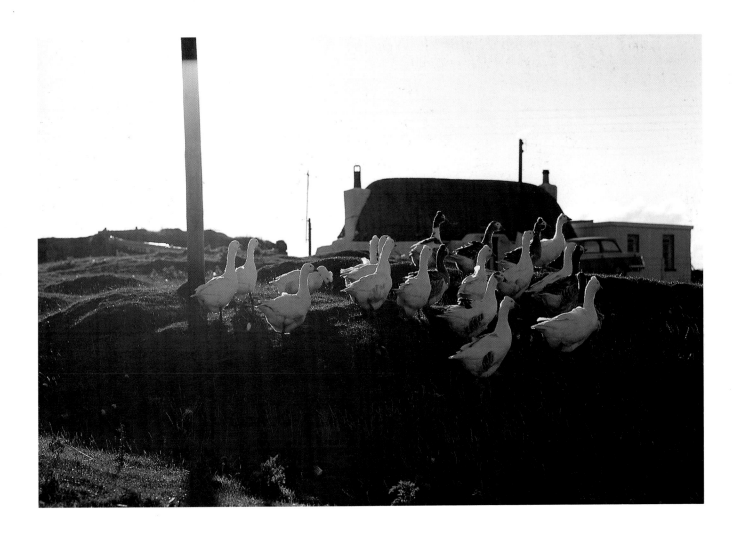

Geese, Tiree

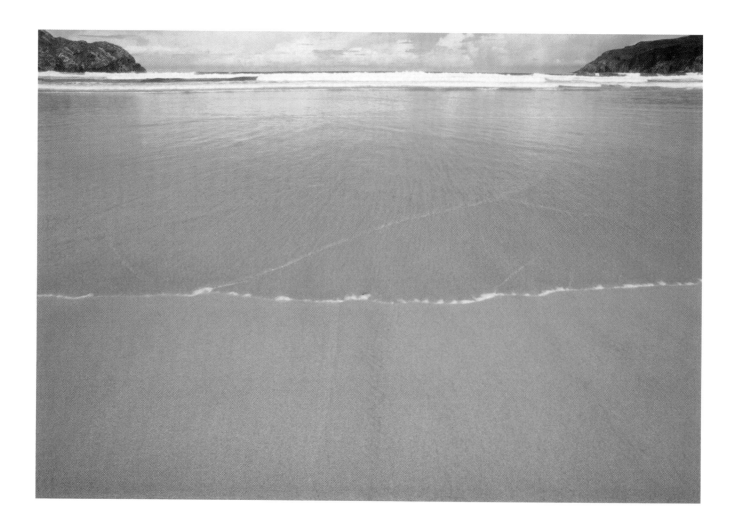

Dalmore, Lewis

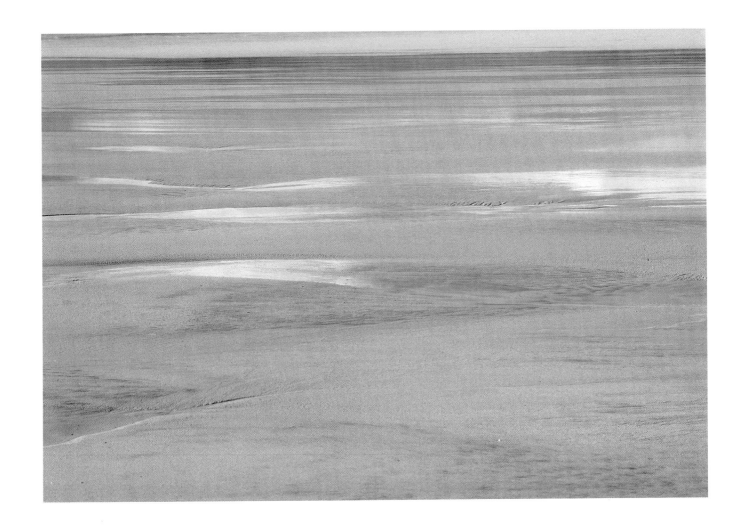

Low tide, Harris

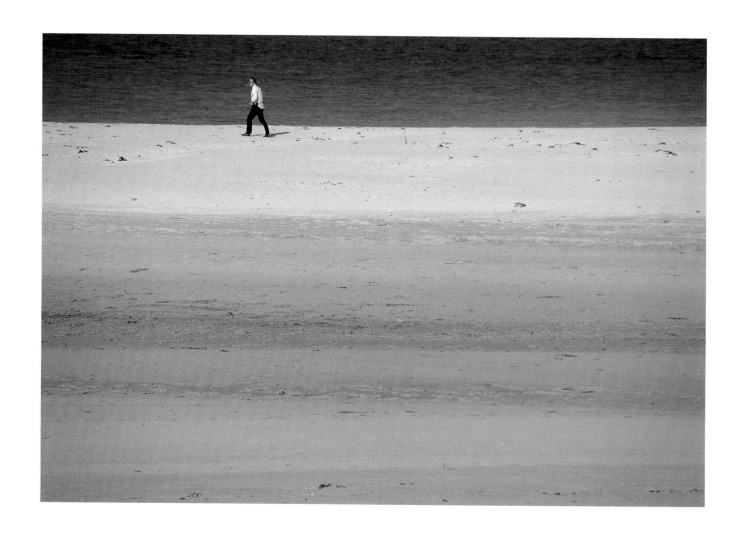

Coll sands, Lewis

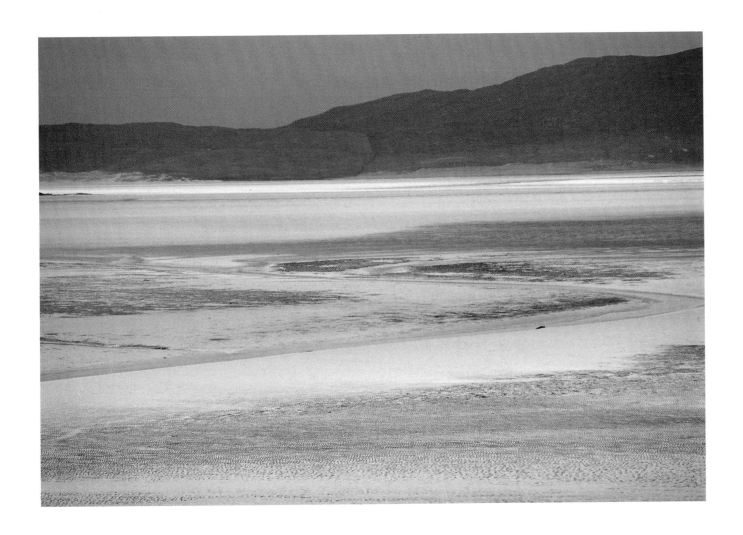

Seaweed and foreshore, Harris

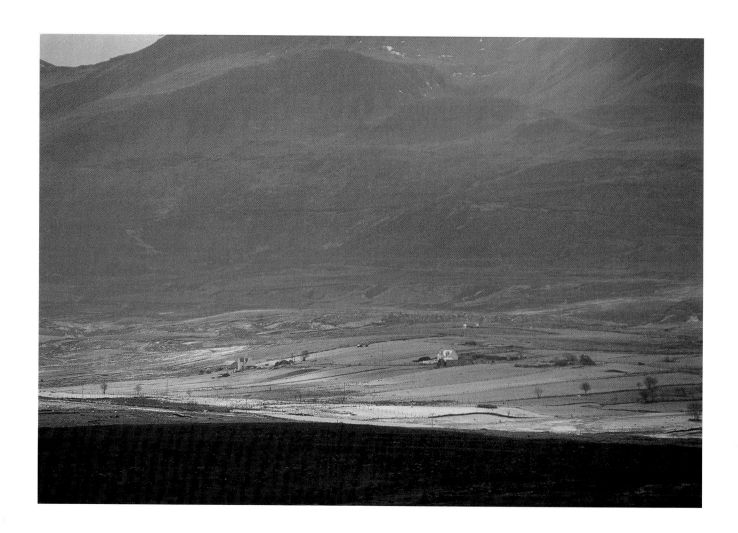

Sun breaking through clouds, Trotternish, Lewis

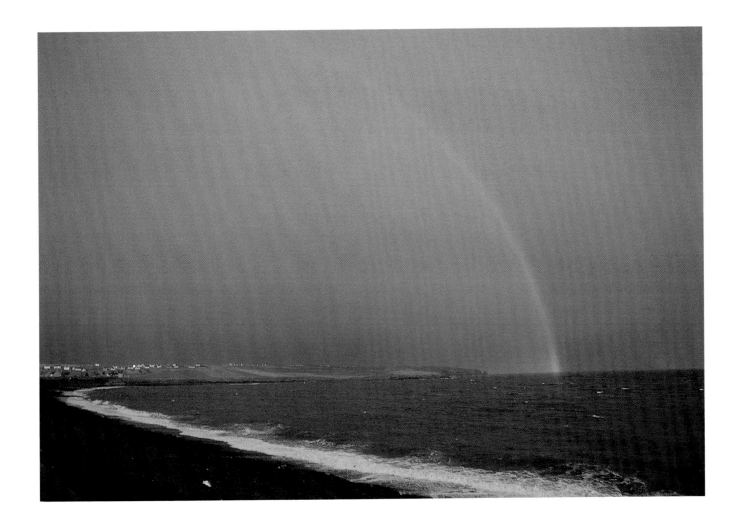

Rainbow, Tongue, Lewis

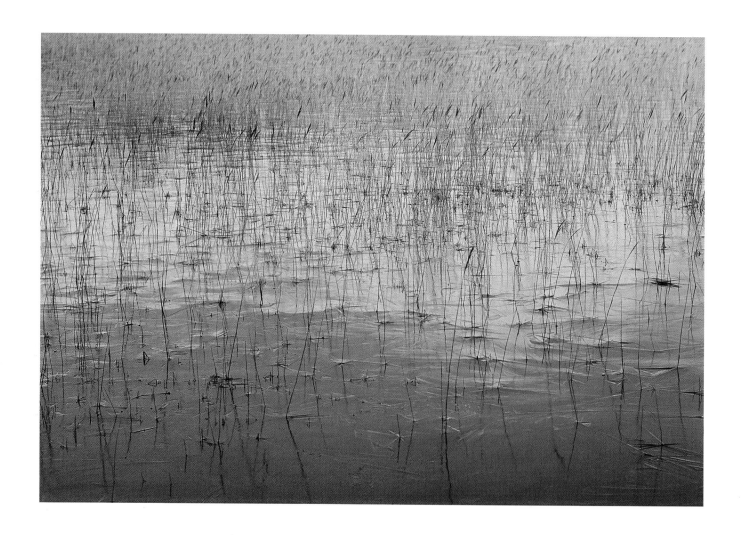

First signs of winter, Lochan, Skye

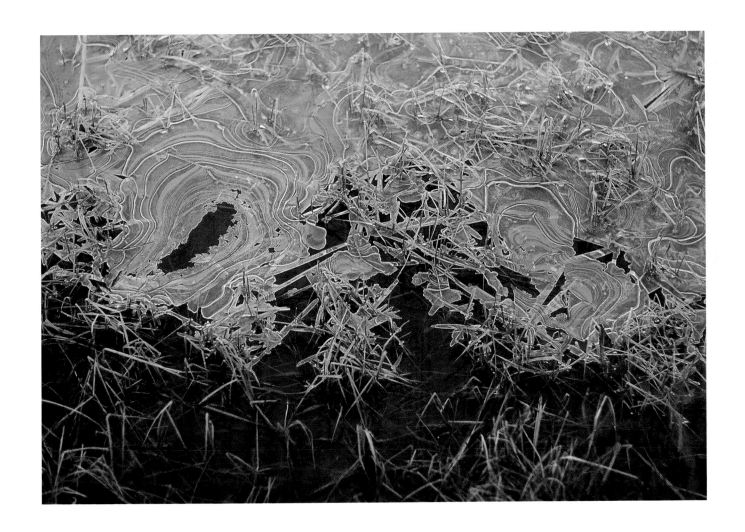

Frozen reeds, Loch Slapin, Skye

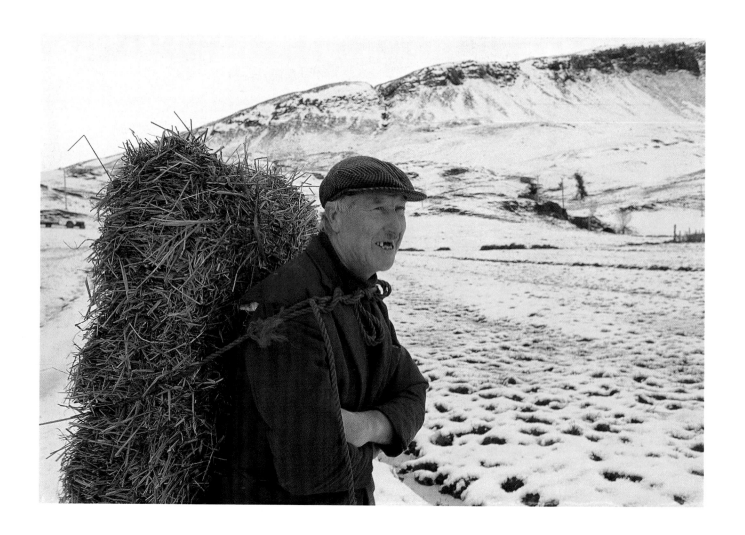

Out with the feed, winter, Skye

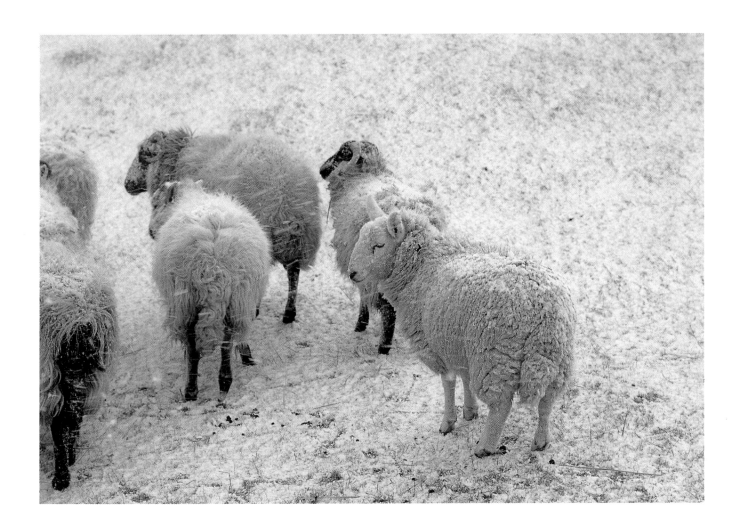

Sheep in snow, Harris

PART THREE — WORK

Shears and dosage, Skye

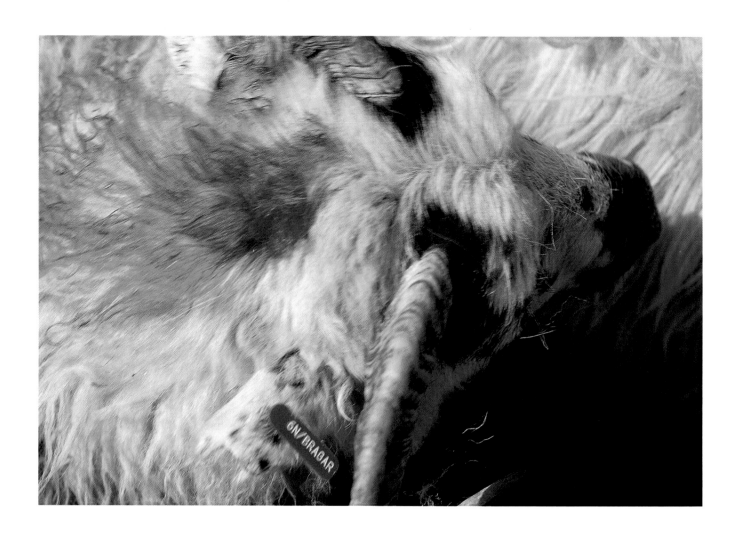

Marked sheep, Bragar, Lewis

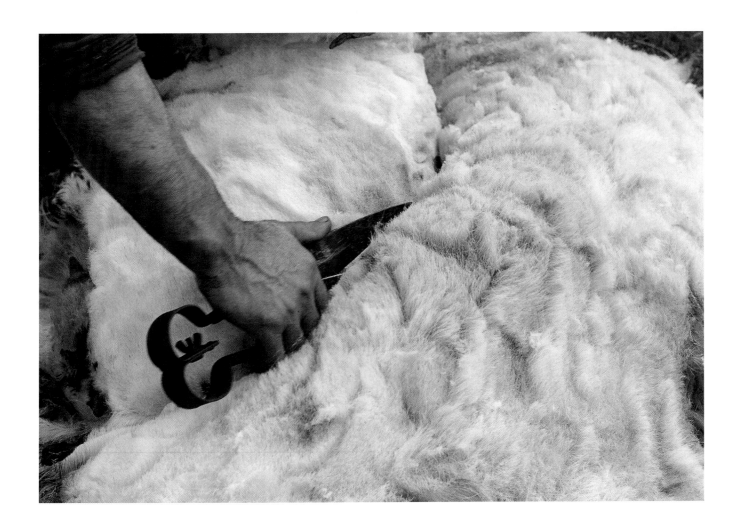

Shearing, The Quirang, Skye

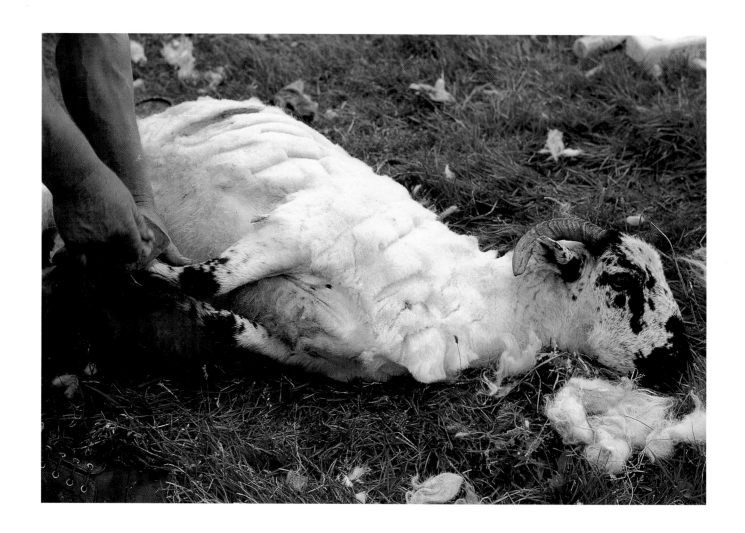

Shorn sheep, The Quirang, Skye

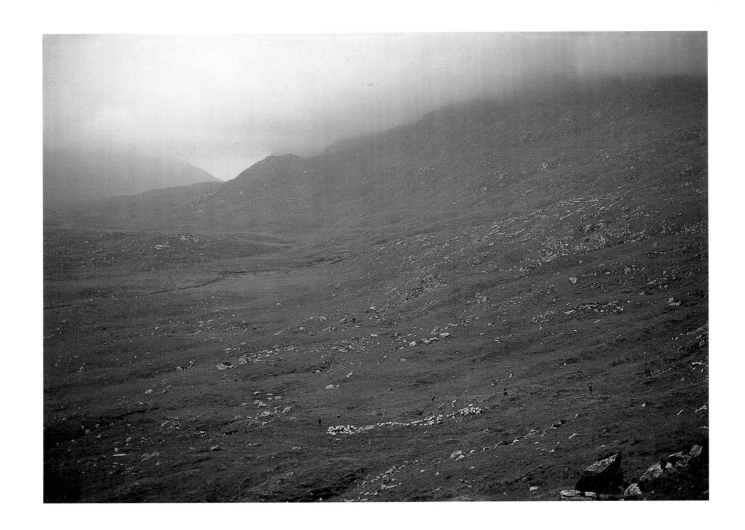

Gathering in the flock, Skye

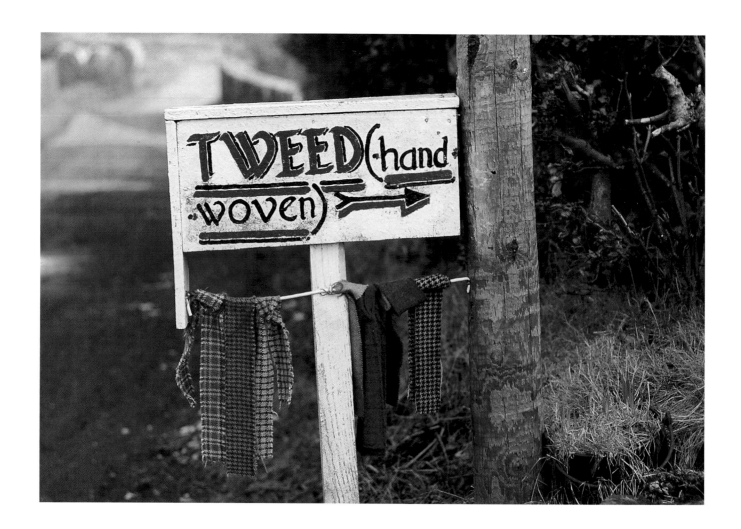

Improvised sign, Harris

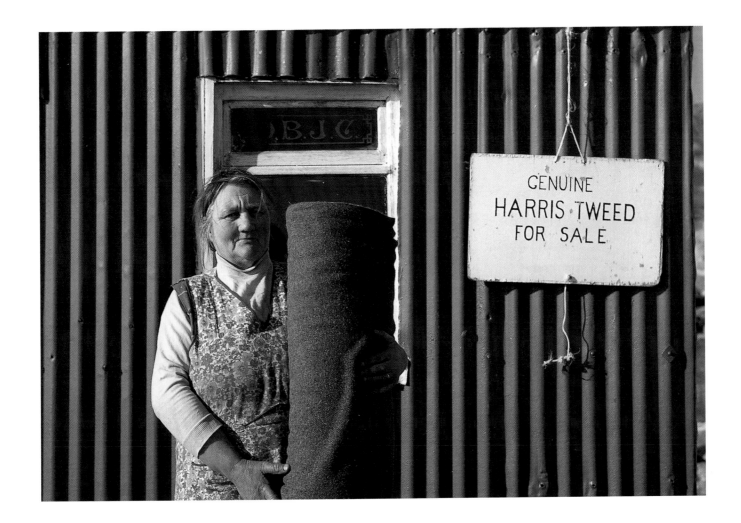

Weaver with her cloth, Harris

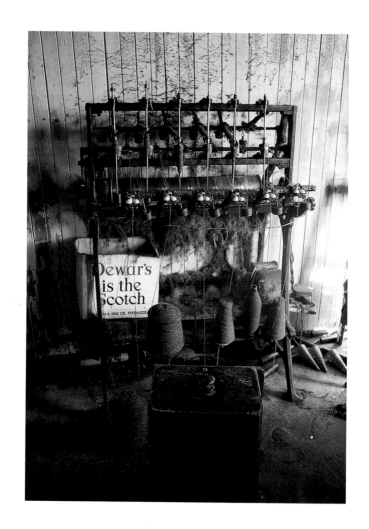

Interior, weaving shed, Harris

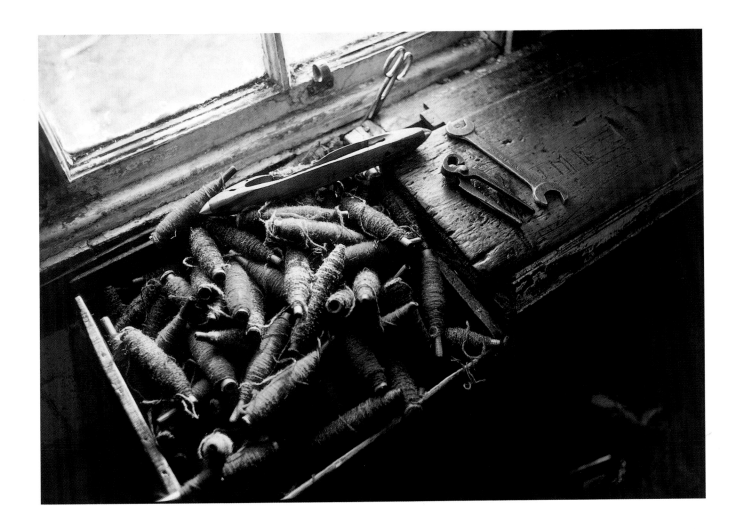

Bobbins, weaving shed, Harris

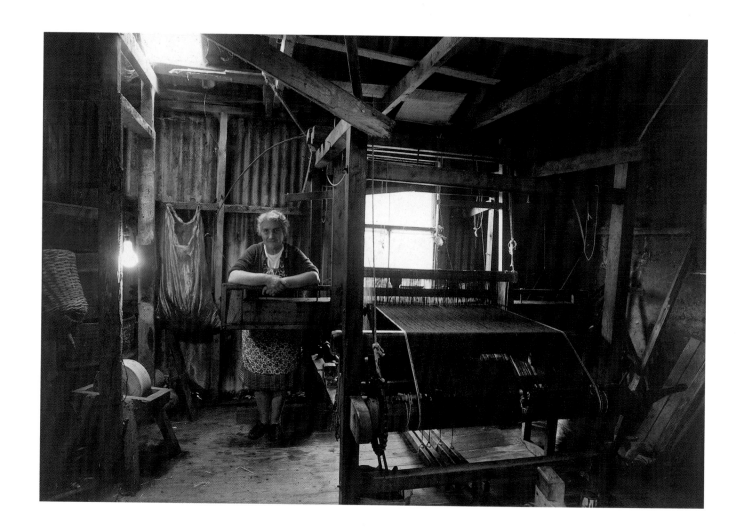

Marion Campbell with her loom, Plocropool, Harris

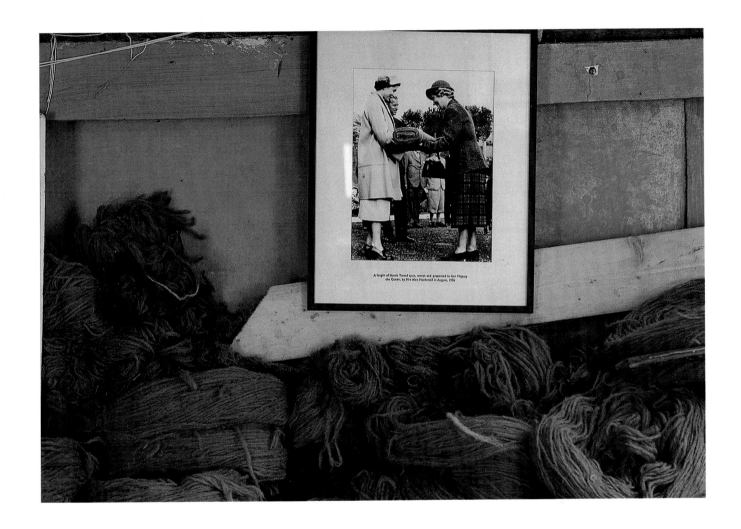

Royal presentation, Plocropool weaving shed

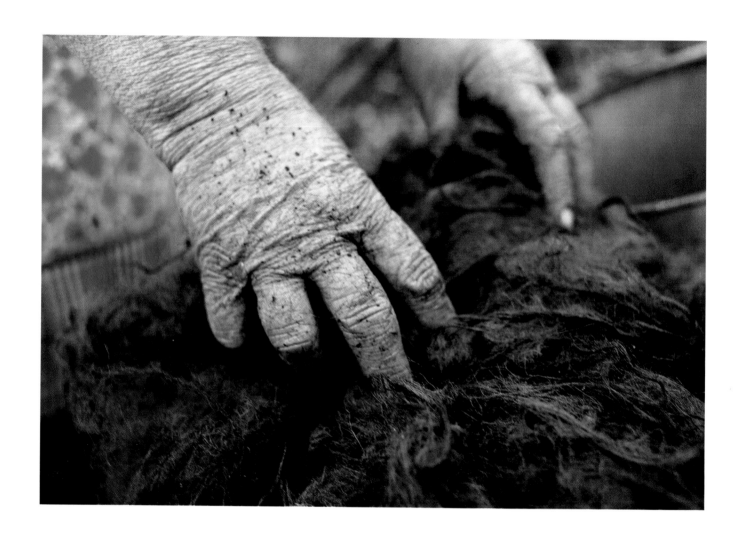

Dying the wool, Plocropool

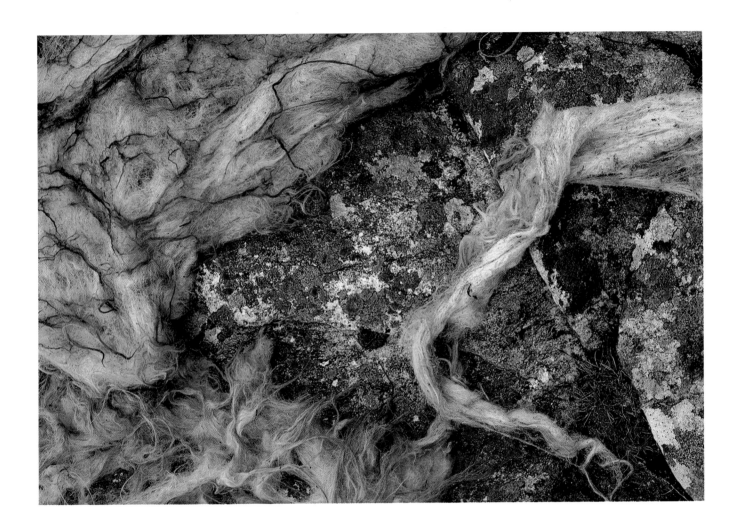

Drying out the wool on the rocks

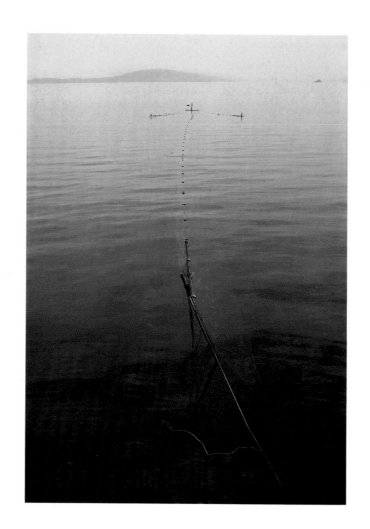

Salmon net, Staffin Island, Skye

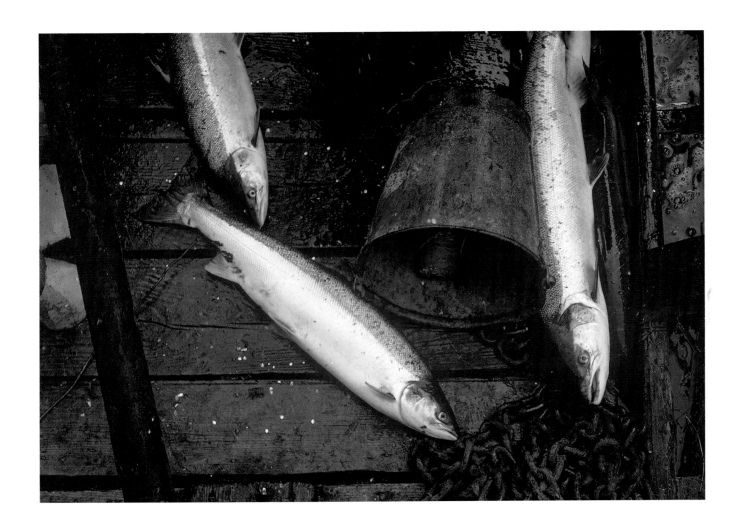

The first of the catch

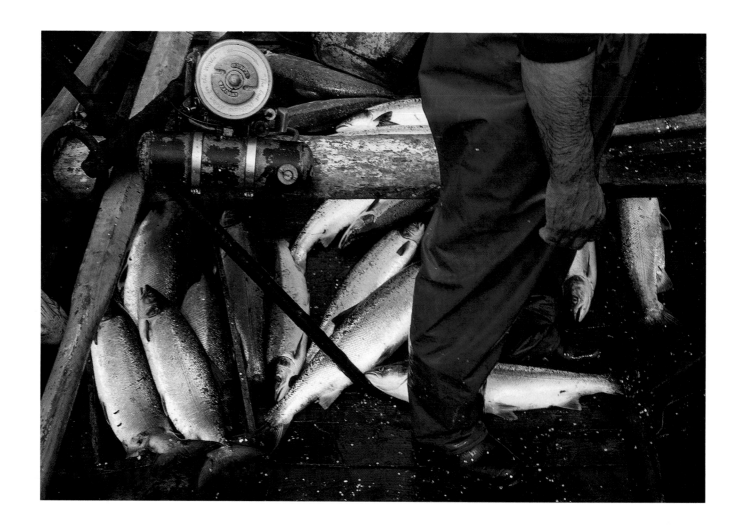

Yet more fish

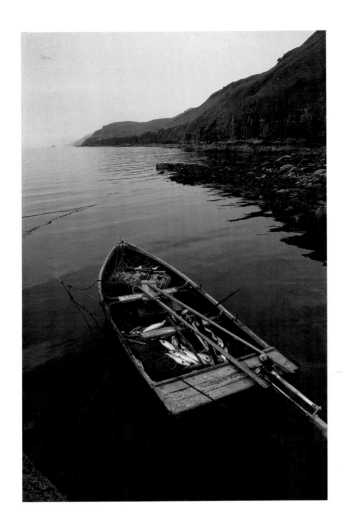

Break for tea, Staffin Island

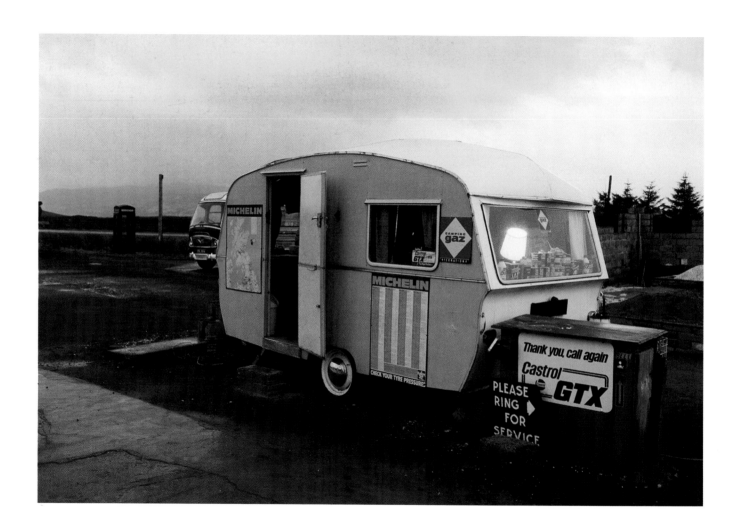

Petrol kiosk, Luib, Skye

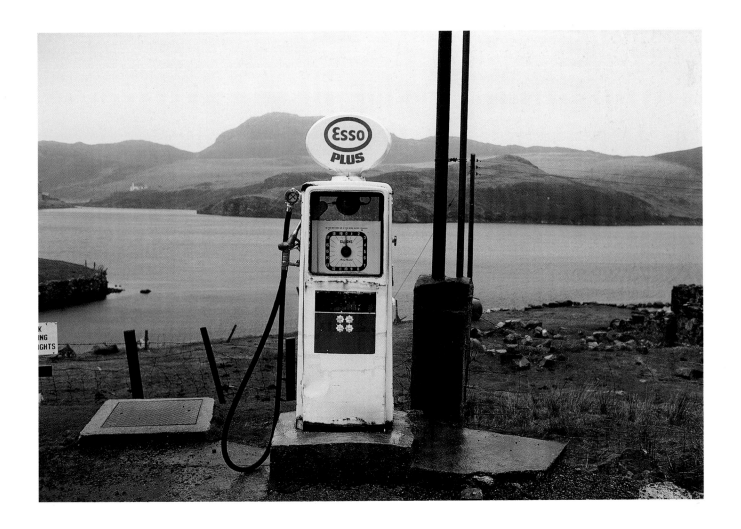

Fuel pump, Bernera, Lewis

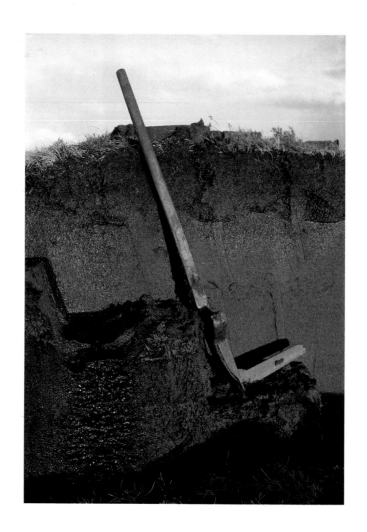

Cas Chrom, the Great Moor, Lewis

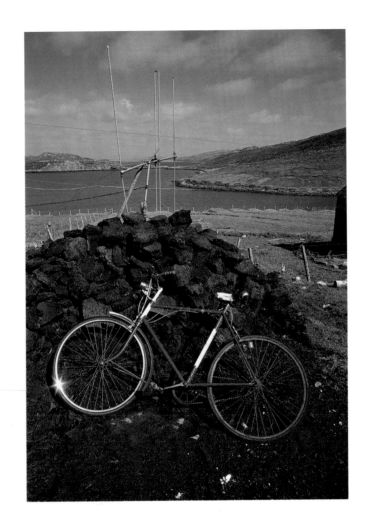

Cycle and peatstack, Lewis

PART FOUR – PEOPLE AND INTERIORS

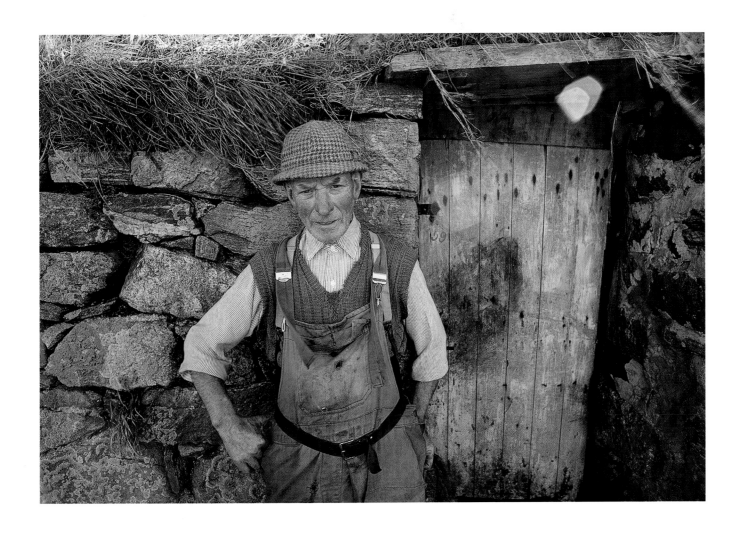

Farmer, Bousd, Isle of Coll

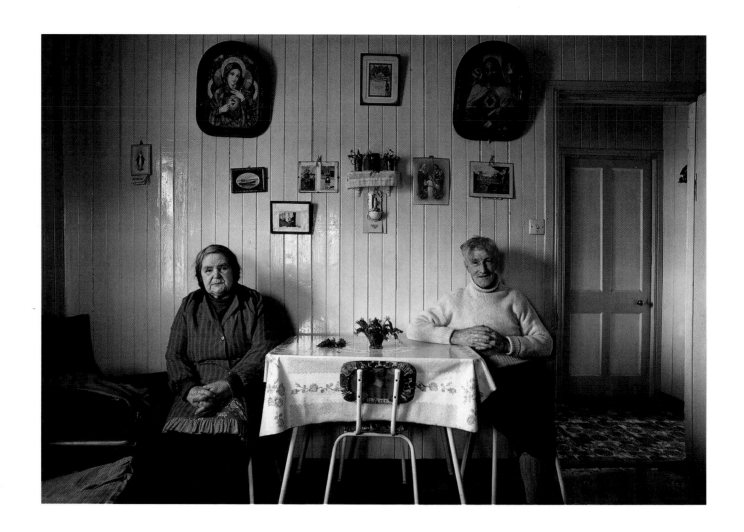

Nan McKinnon and Jonathan MacLeod, Vatersay

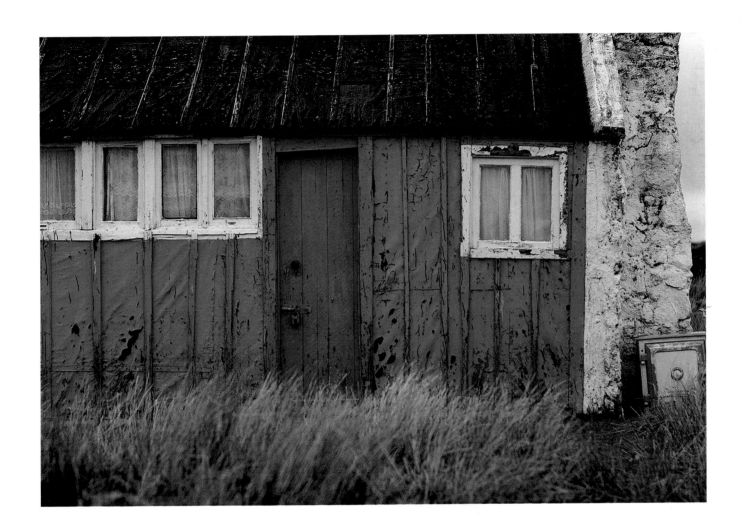

Shieling, the Pentland Road, Lewis

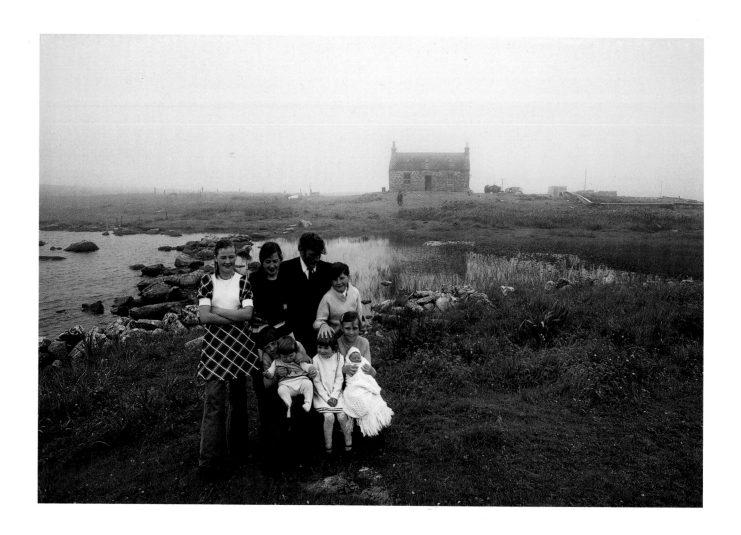

Family group, Bornish, South Uist

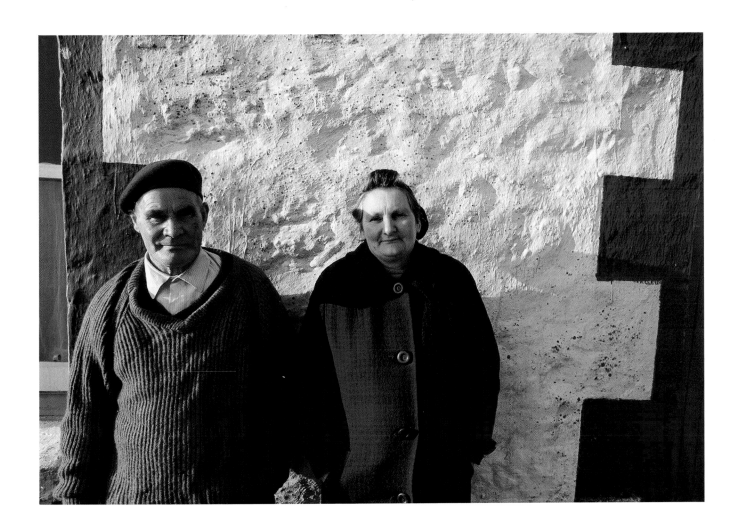

Couple, Tote, Skye

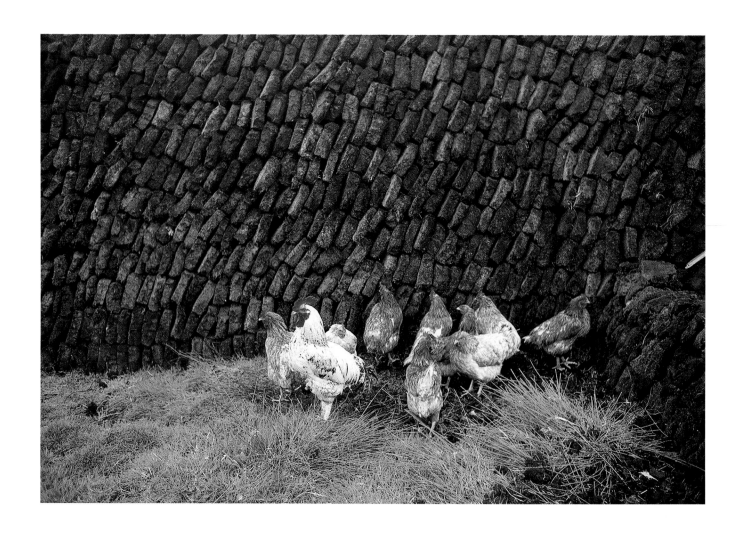

Hens and peat, Lewis

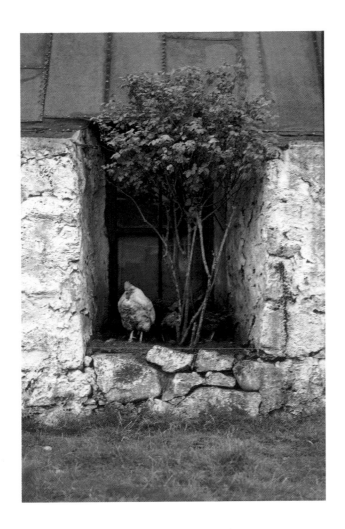

Cockerel and window, Coll

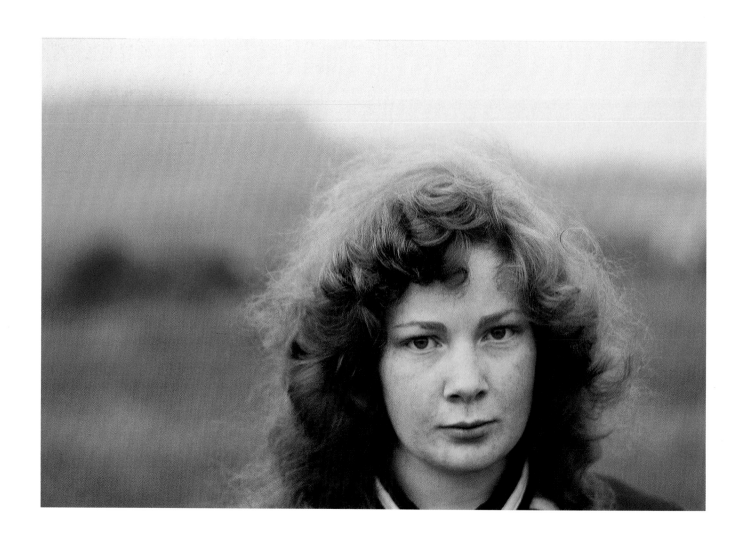

Young red-haired girl, Staffin, Skye

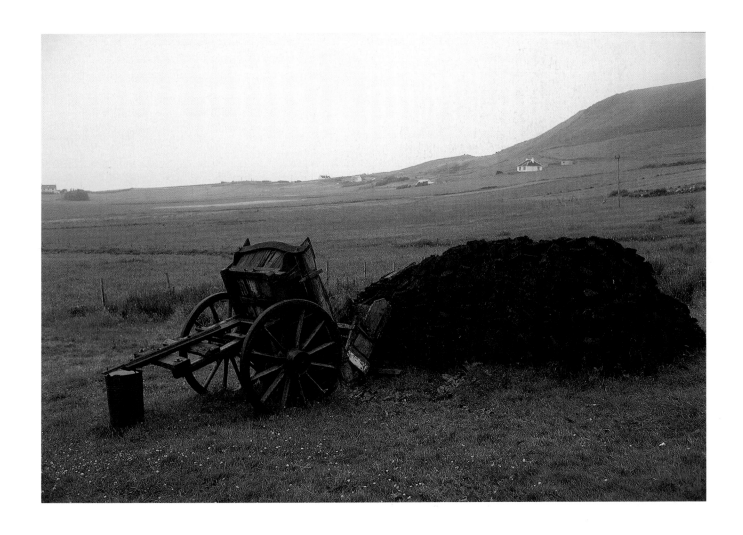

Red cart, Kilmuir, Skye

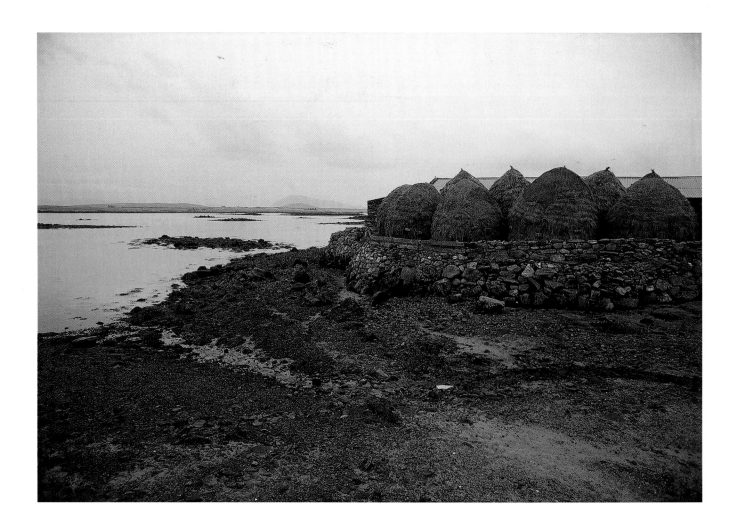

Haystacks, Baleshare, North Uist

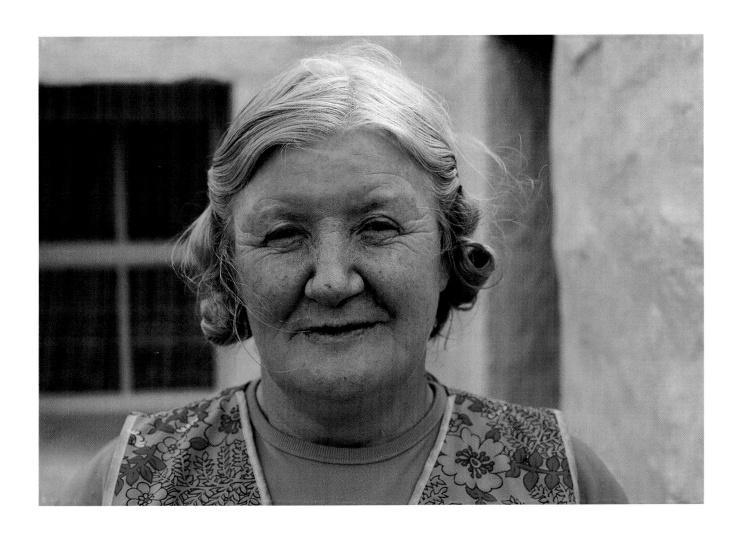

Smiling woman, Claddach Baleshare, North Uist

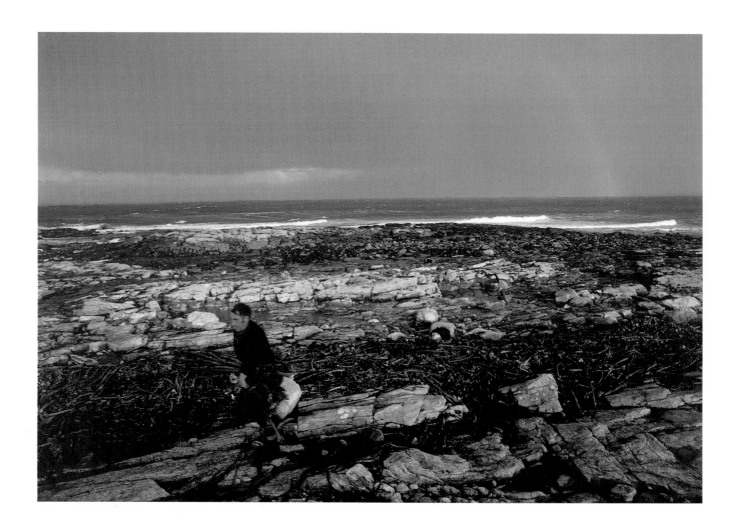

Seaweed gatherer, Rudha Ardvule, South Uist

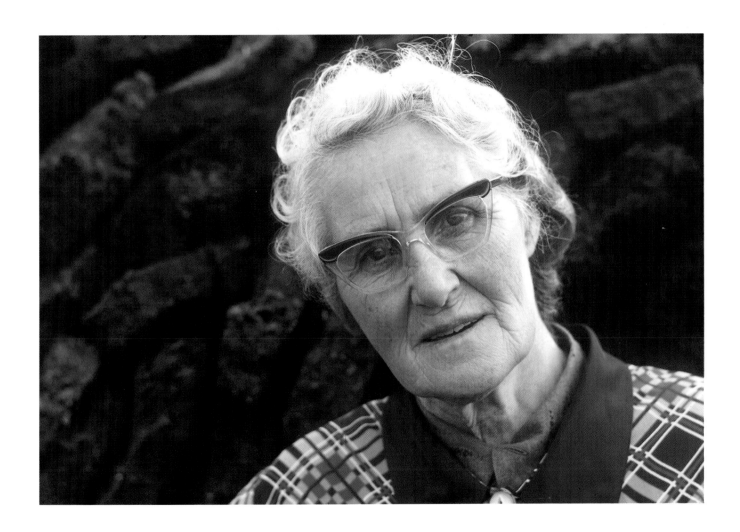

Woman and peat stack, Lewis

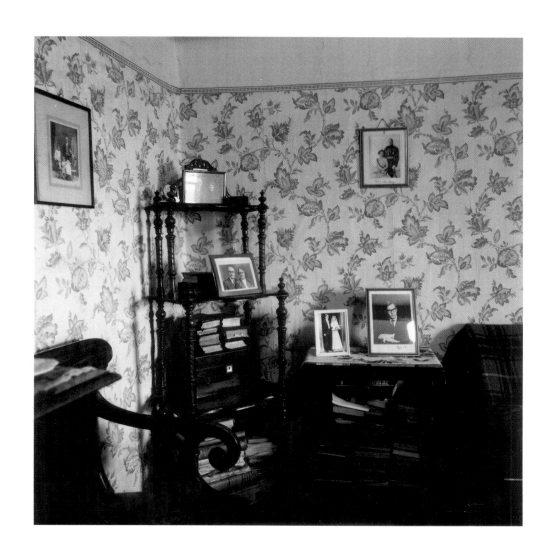

Royal souvenirs, Achmore, Lewis

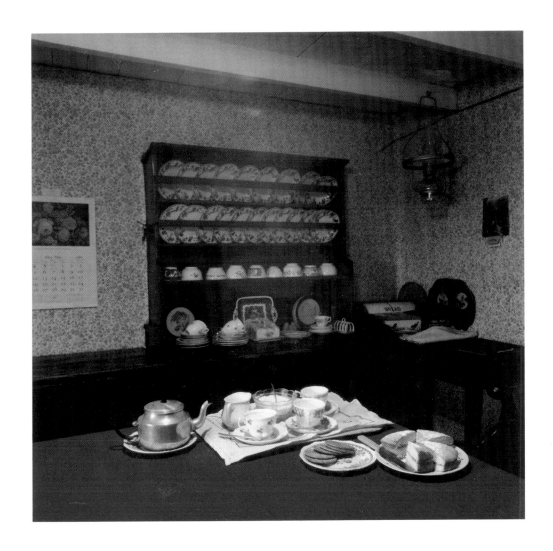

Welcoming spread, Achmore

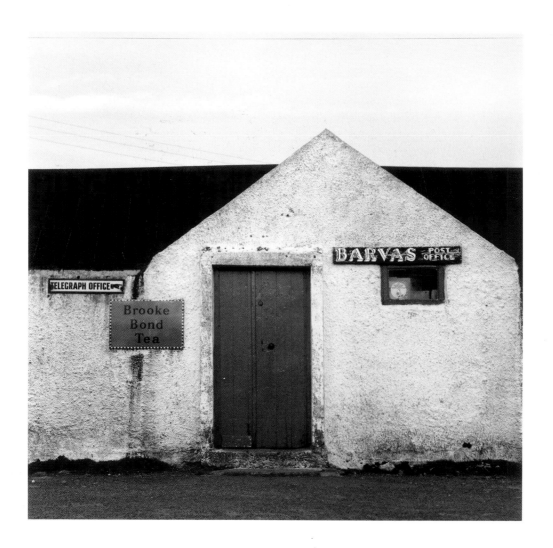

The old Post Office, Barvas, Lewis

The red dress, near Arnol, Lewis

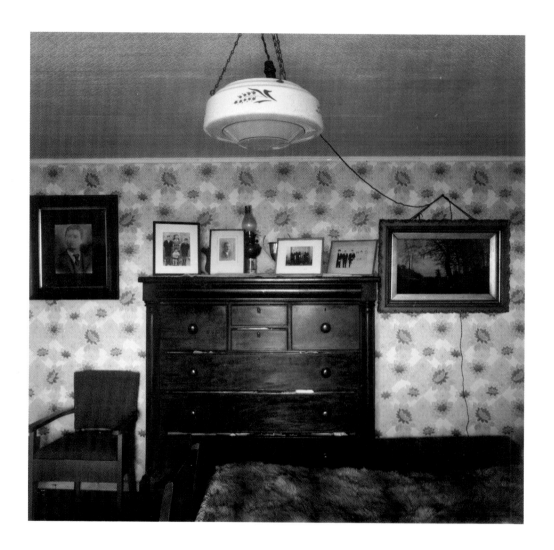

The pink lampshade, Laxay

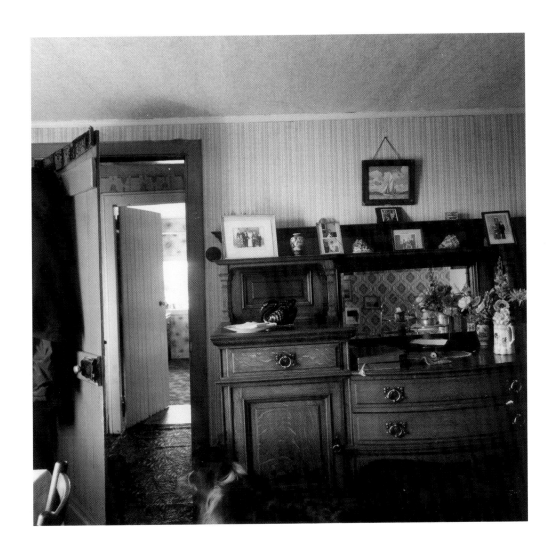

Interior, Laxay, Lewis

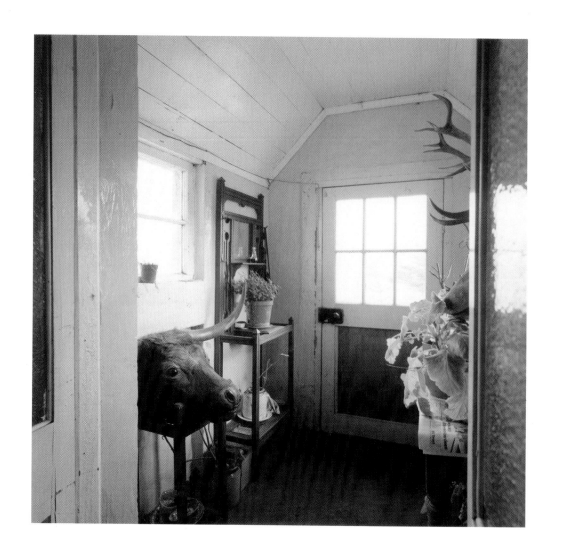

Porch, North Duntulm, Skye

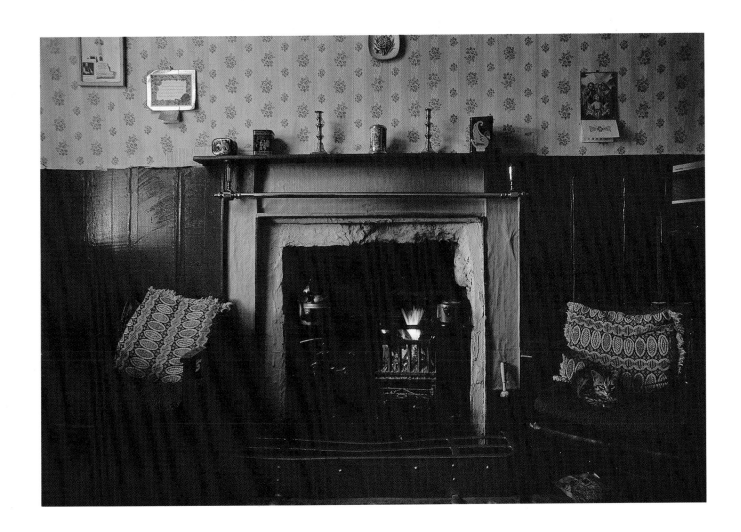

Fireplace, South Lochboisdale, South Uist

PART FIVE– LAND AND WATER

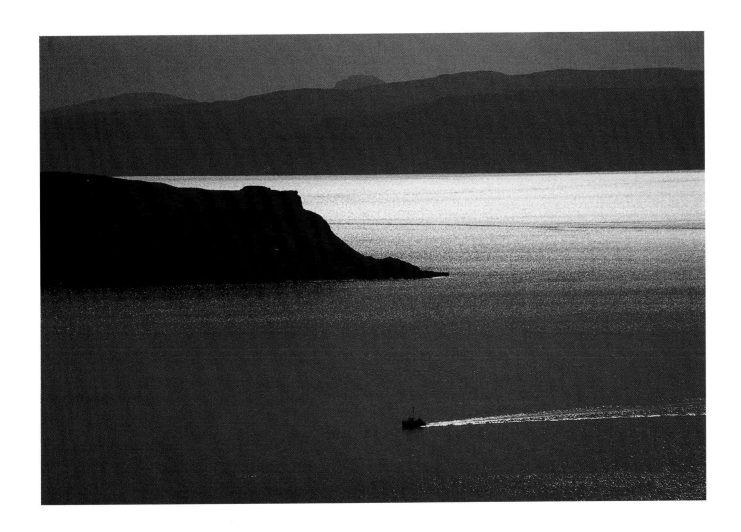

Returning fishing boat, Uig, Skye

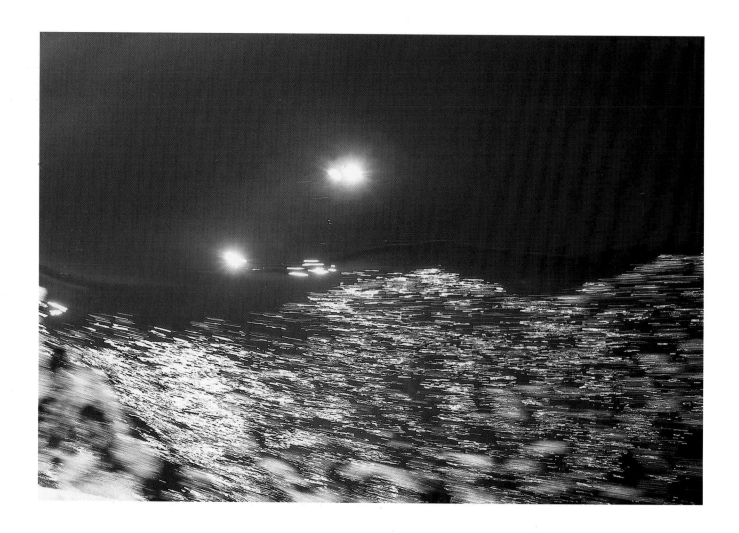

Sun on water

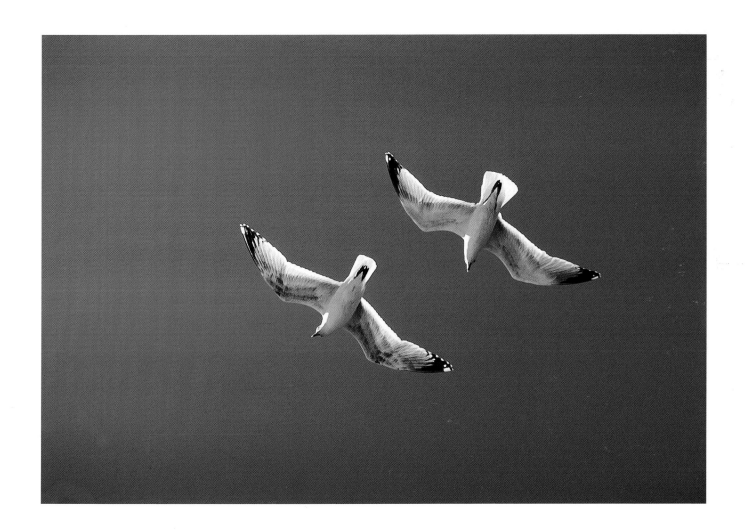

Hovering gulls

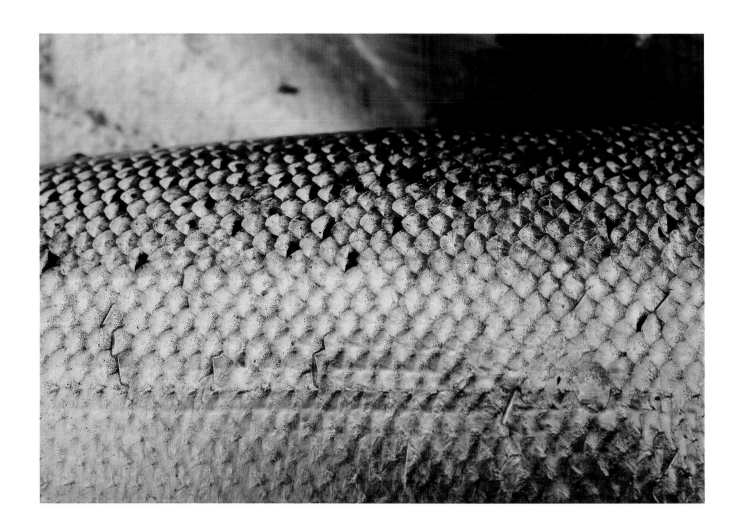

Freshly caught salmon, Skye

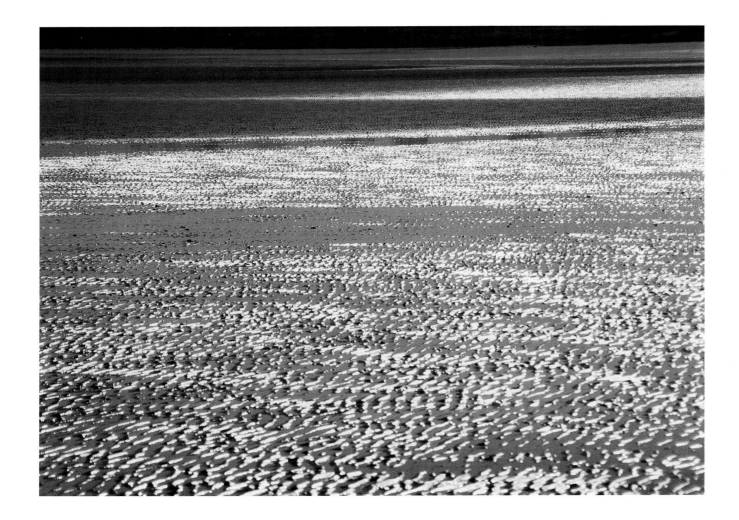

Light on foreshore, Coll, Lewis

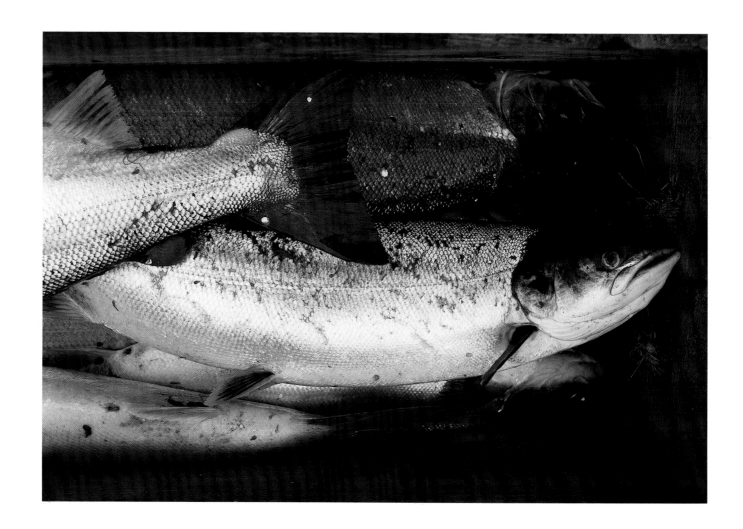

The salmon catch, Skye

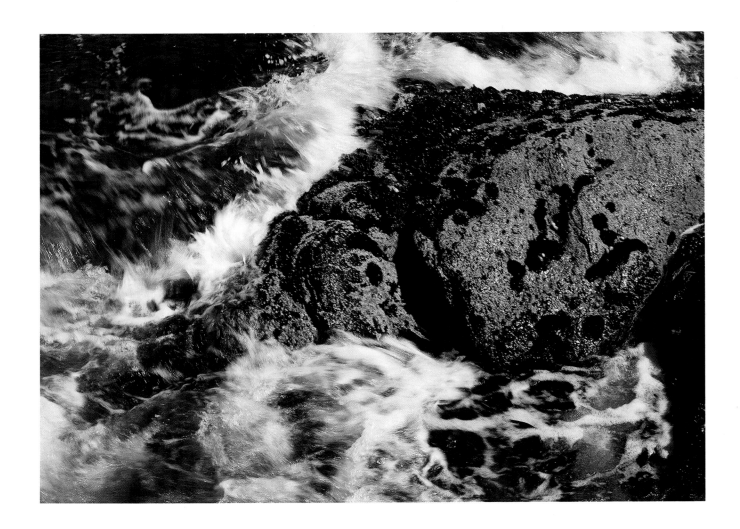

Wave breaking over rock

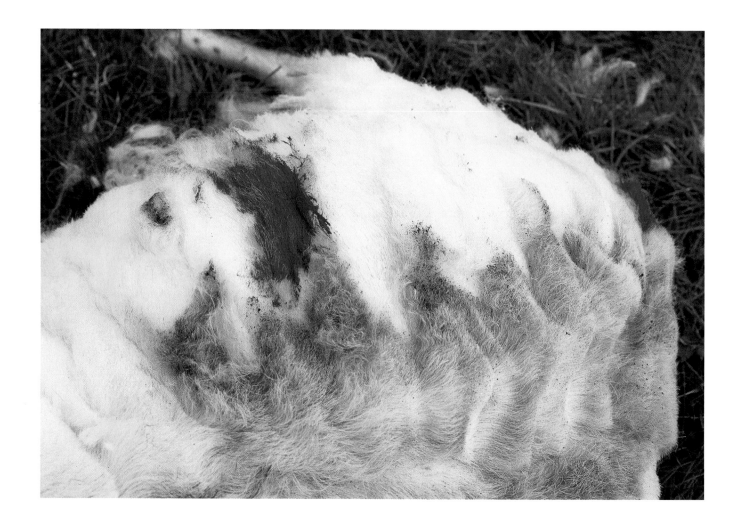

Fleece

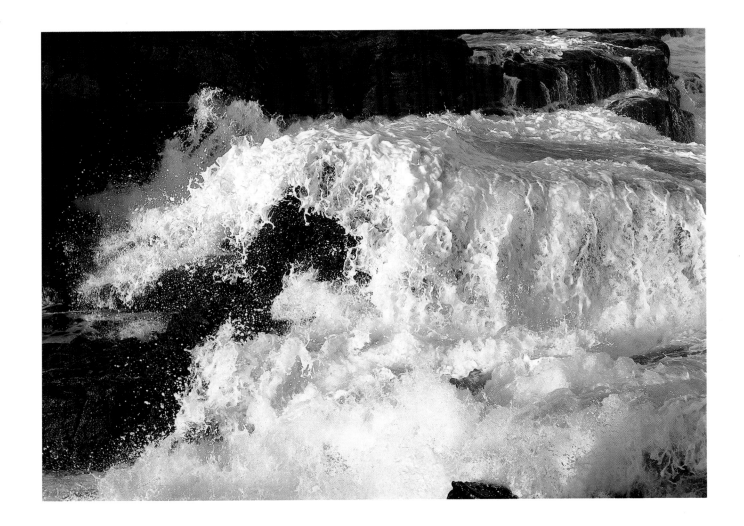

Waterform

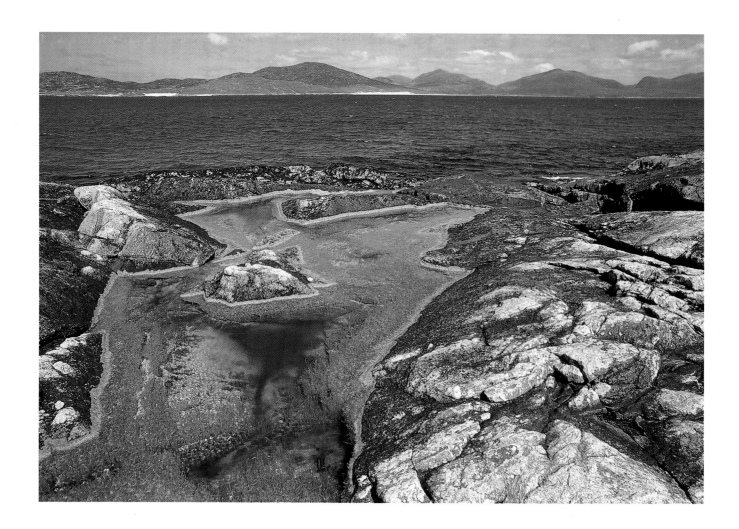

Tidal marks on rocks, Harris

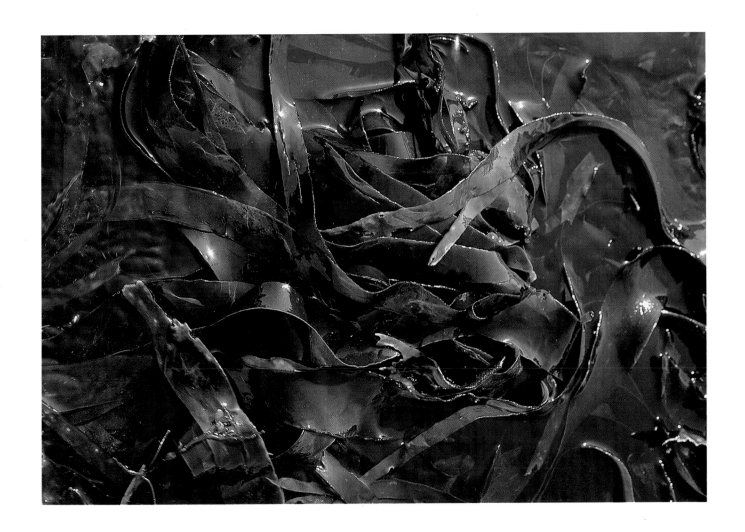

Seaweed, Rudha Ardvule, South Uist

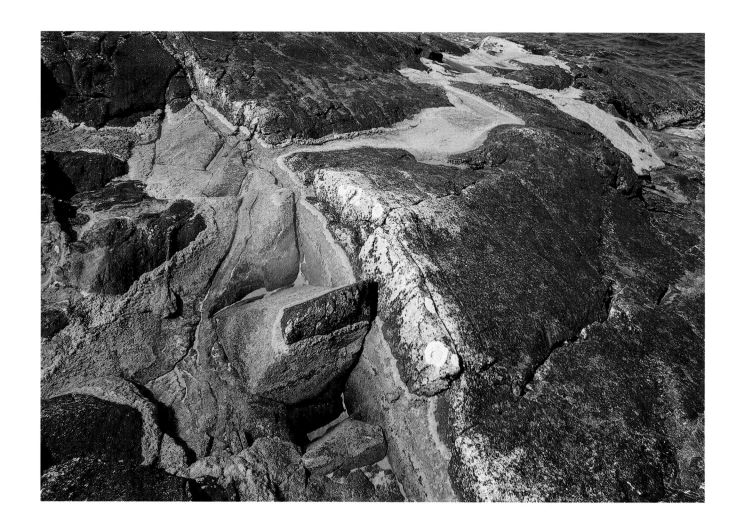

Tide marks, Harris

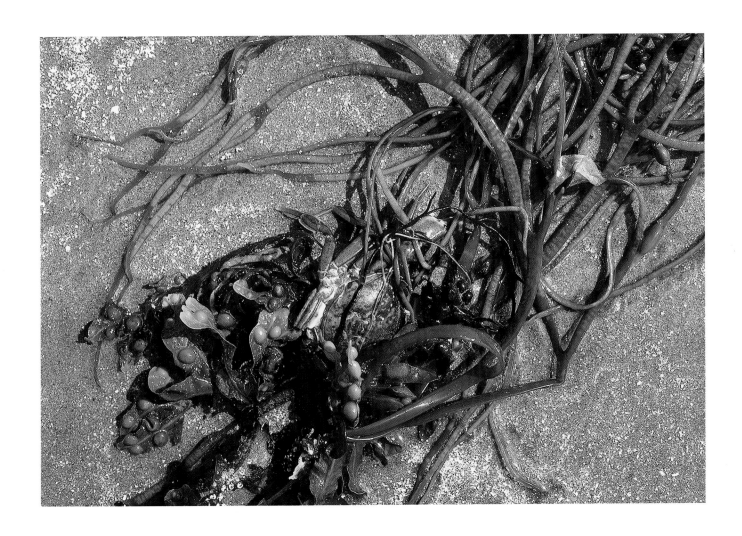

Seaweed on the foreshore

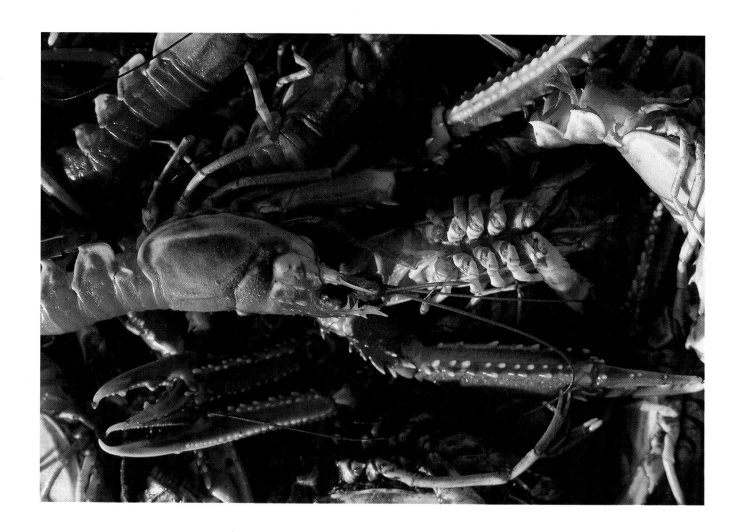

Prawns, North Uist

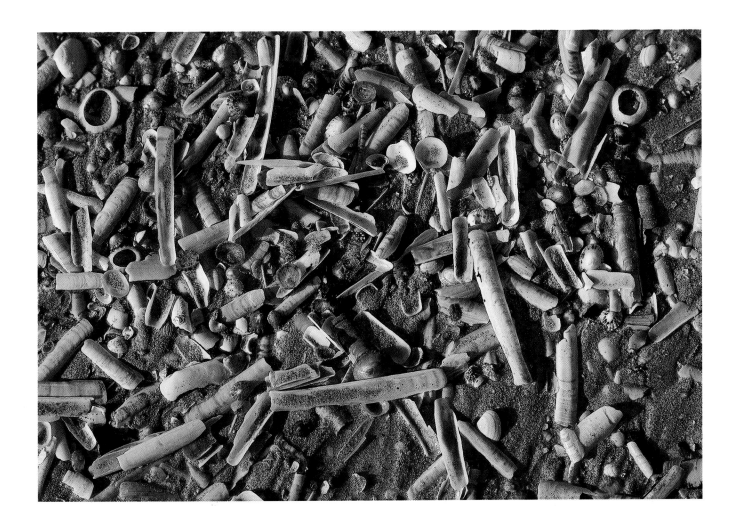

Razor shells

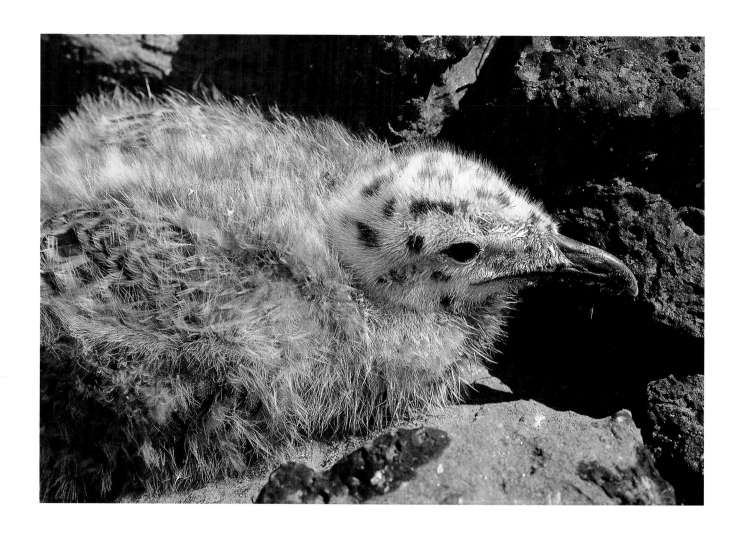

Young gull, South Uist

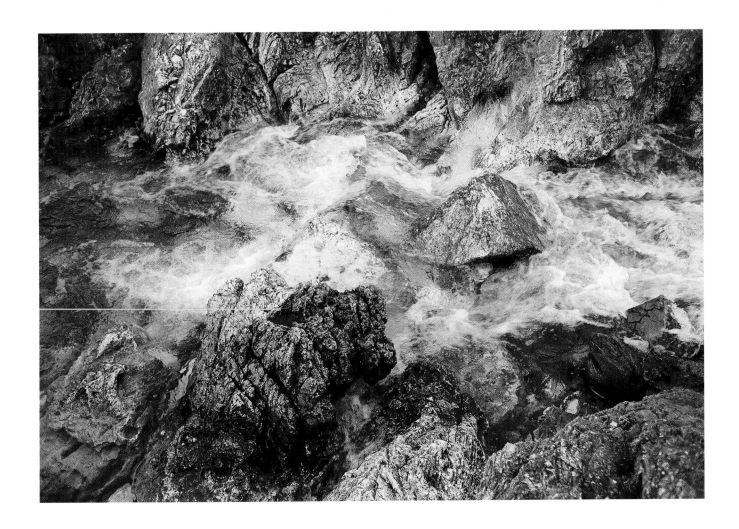

Waterforms and Granite

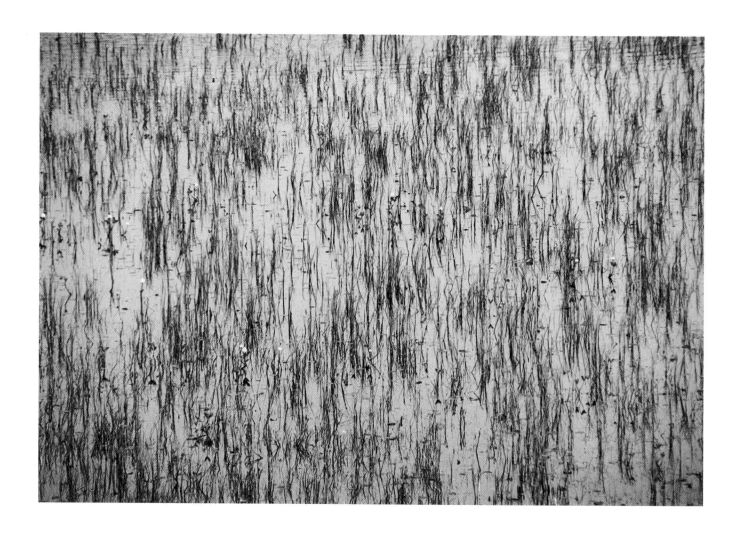

Green lochan

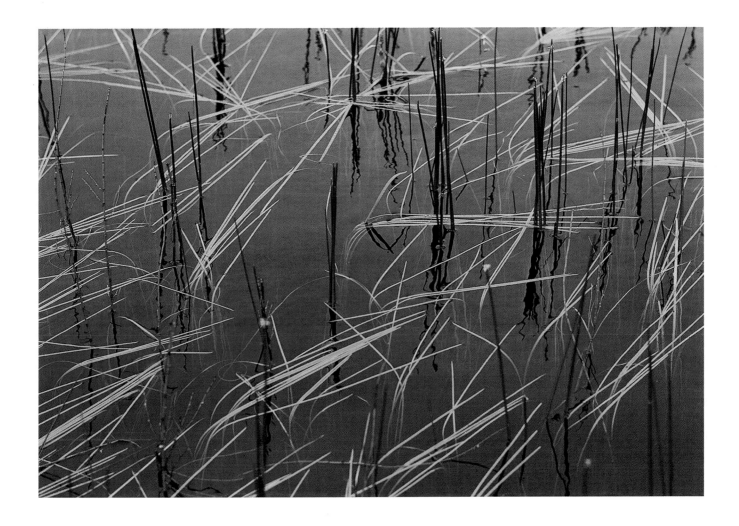

Reeds

PART SIX— HEARTLAND

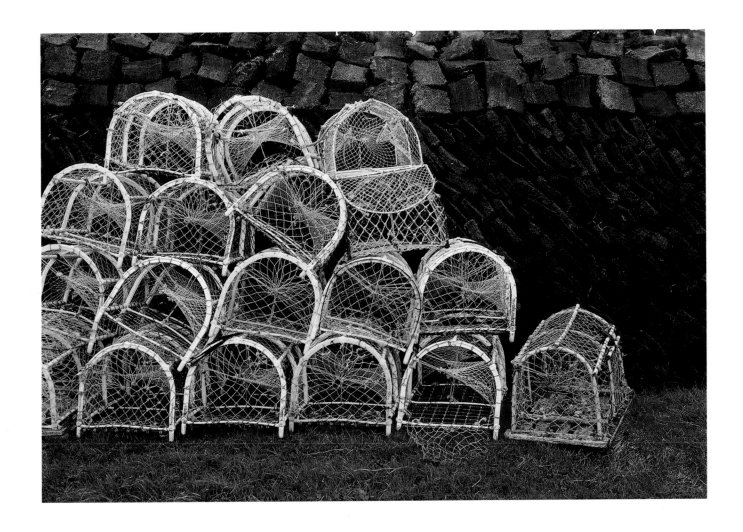

Creels and Peat

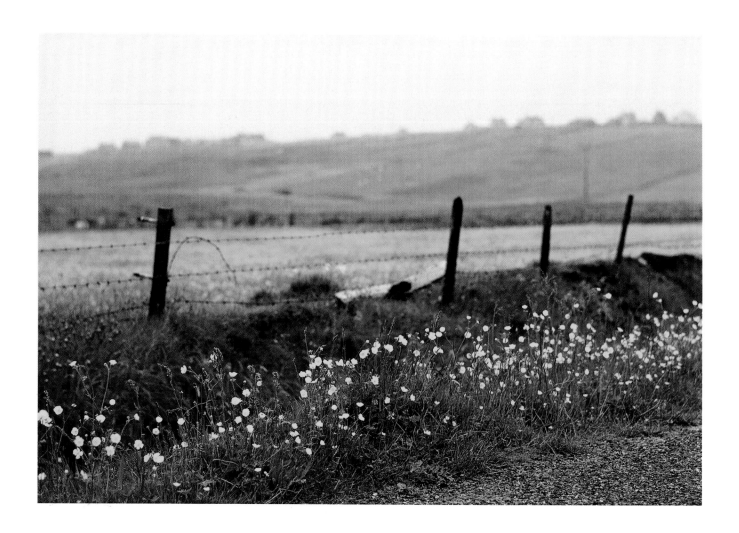

Wild flowers, Lewis

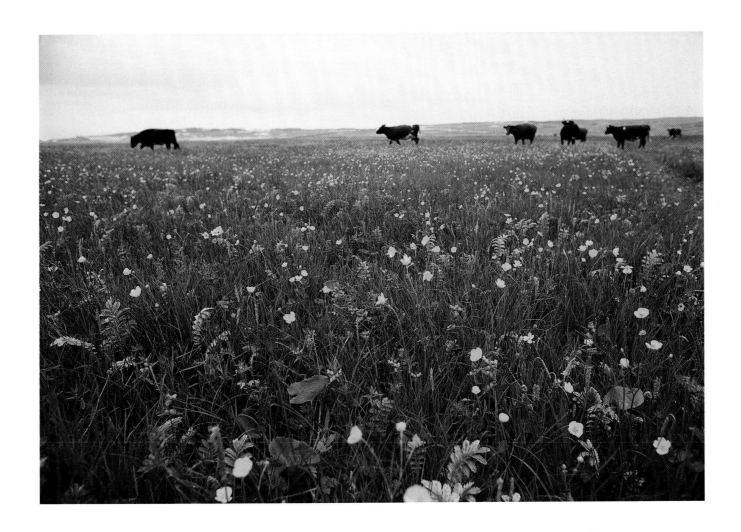

Buttercups and cattle, Lewis

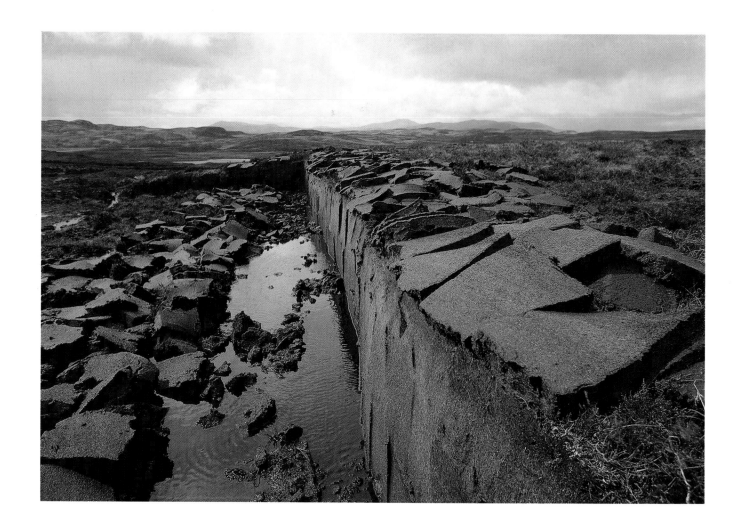

Peat run, Lewis

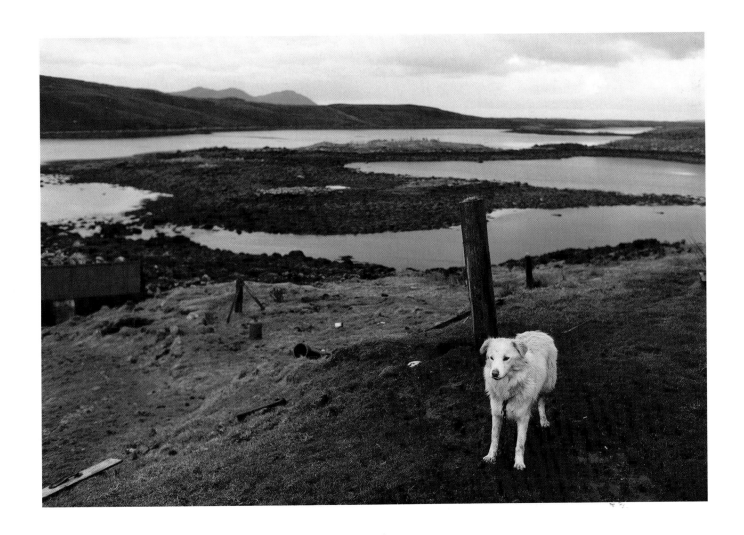

White dog, Loch Portain, North Uist

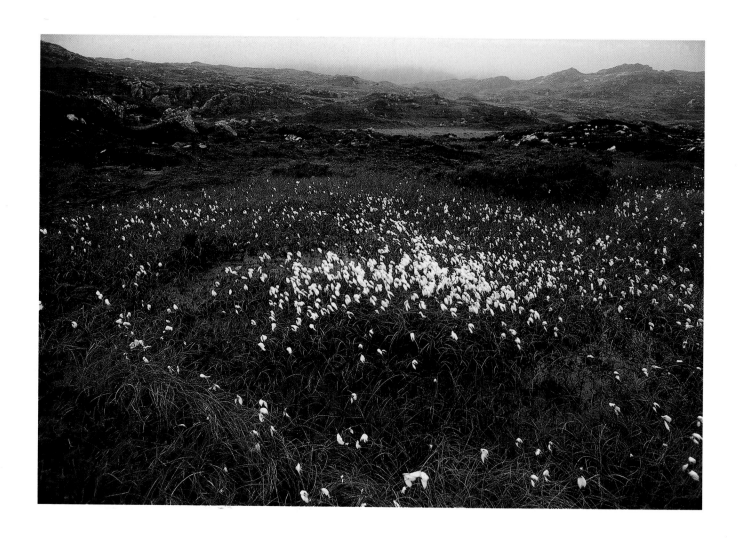

Bog cotton, Harris

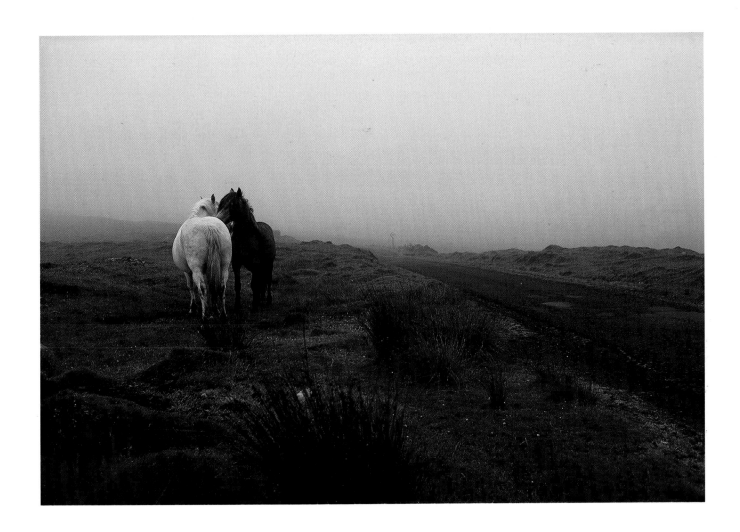

Two horses, Duntulm, Skye

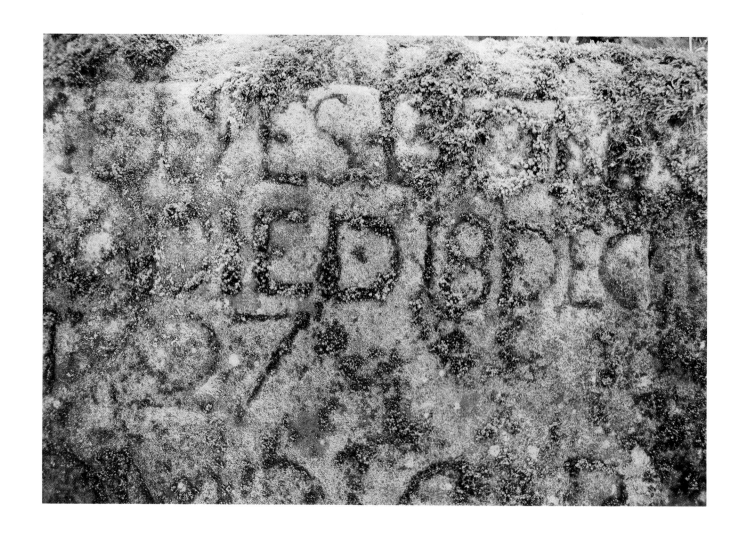

Lichen and gravestone, Skye

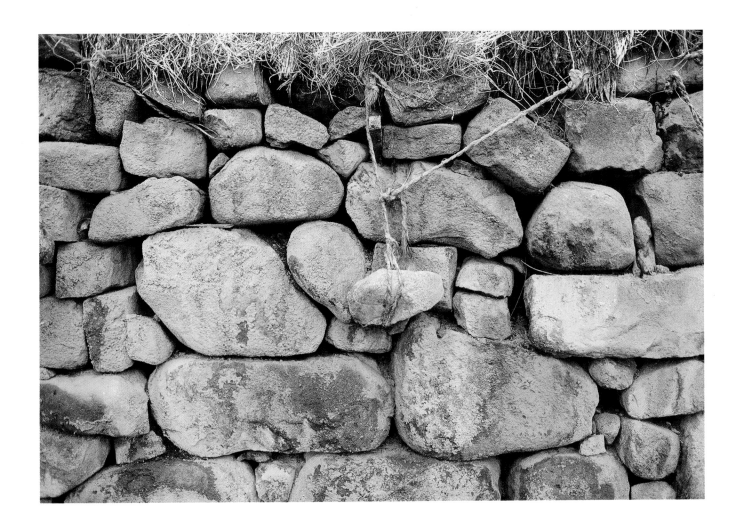

Green Wall, Hungladder, Skye

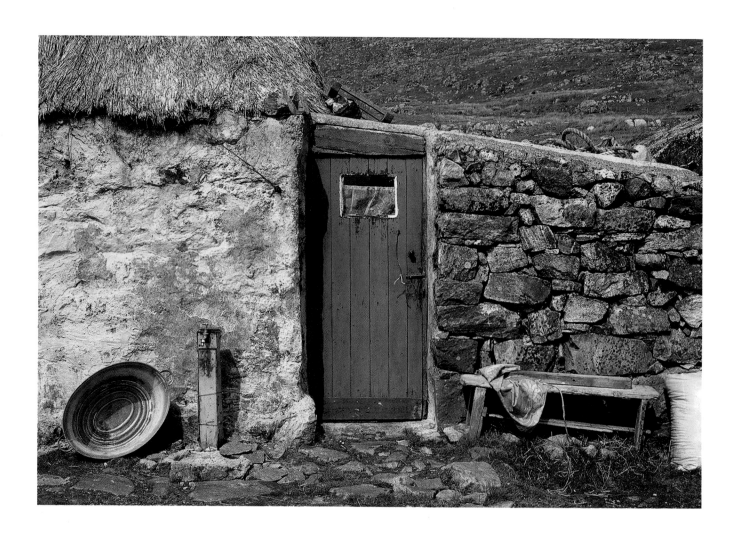

Pink door and bath tub, Harlosh, Skye

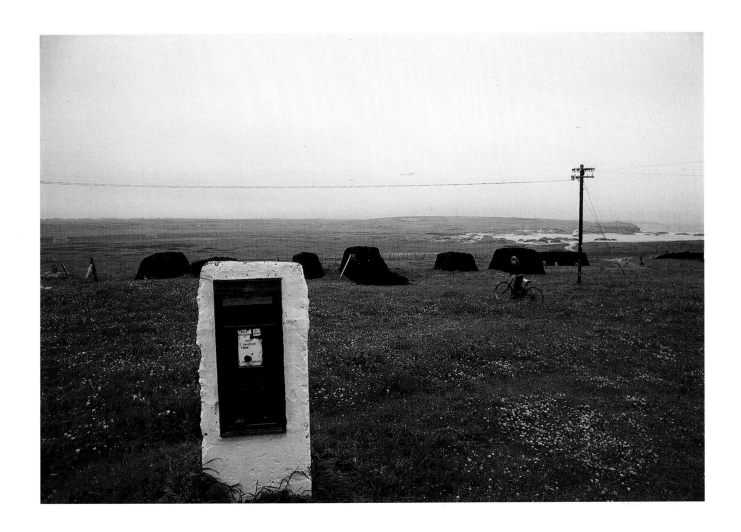

Post box, Ness, Lewis

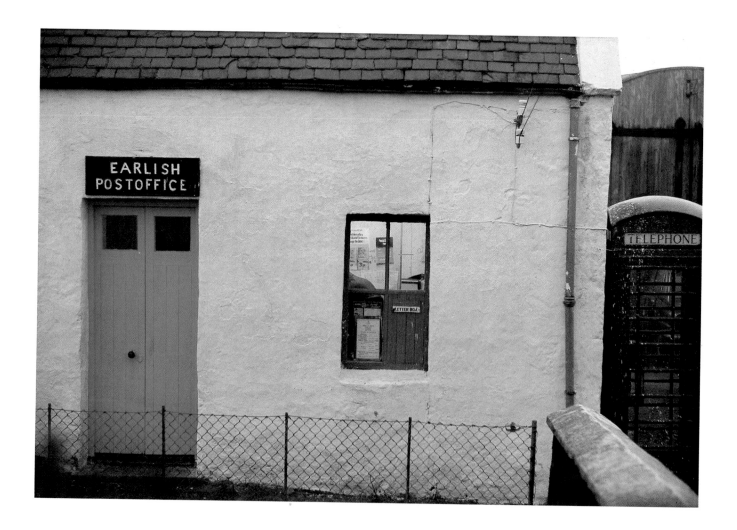

Post office at twilight, Earlish, Skye

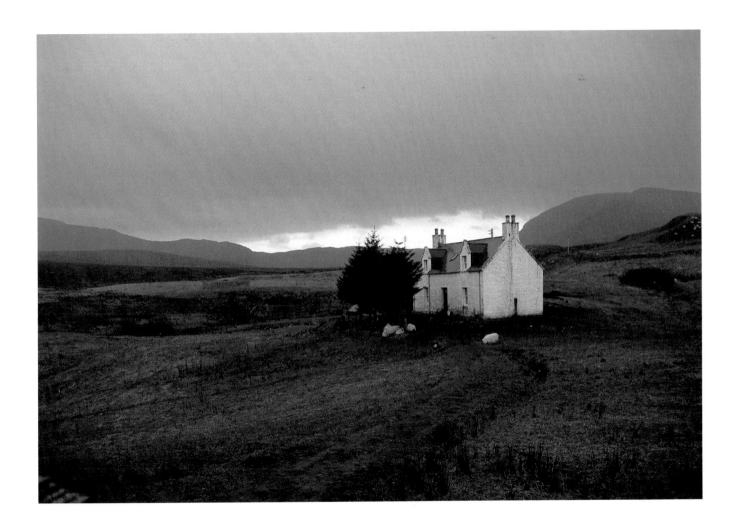

Afterglow, Staffin, Skye

GUS WYLIE was born in Lowestoft, Suffolk in 1935, and spent the war years as a child in East Fife. He graduated from the Royal College of Art in Fine Art in 1960, and began a career in education that lasts to the present day. Whilst a Senior Lecturer in Photography at the Polytechnic of Central London, he read for a Masters in Photography at the Royal College, before teaching there from 1984 to 1992, during which time he gained a PhD in Cultural History. After a Professorship in New York, he resumed his teaching in this country in a part-time capacity, on courses in Photojournalism and is currently teaching on the new Degree in Fashion Photography at the London College of Fashion. His previous books include two on the Western Isles of Scotland, *The Hebrides* and *Patterns of the Hebrides*; he has exhibited this work extensively and a further book is proposed for next year. Most recently, he was represented in *The Great Book of Gaelic* as a visual artist illustrating a poem by Murdo Morrison.